Julio Larraz

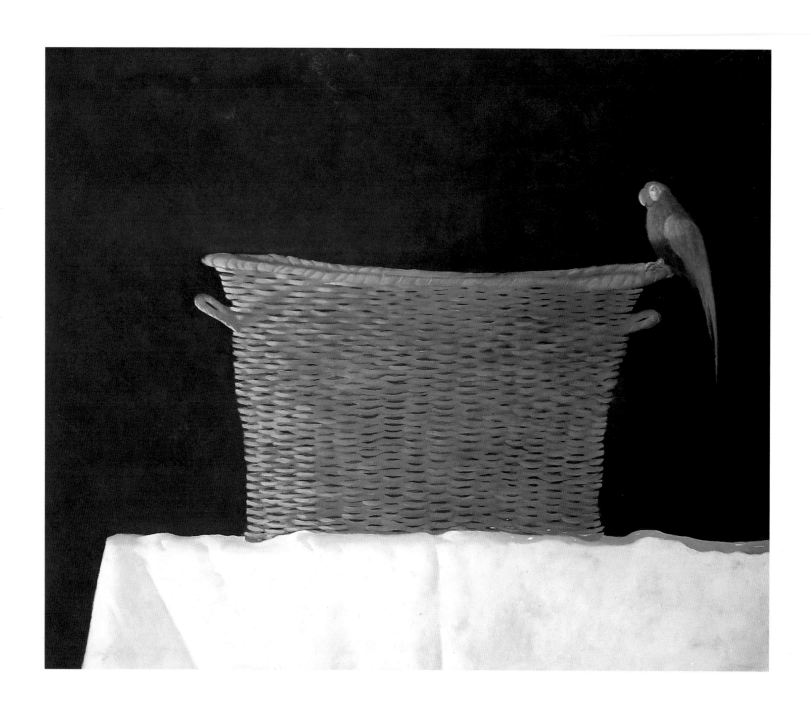

Julio Larraz

by Edward J. Sullivan

Hudson Hills Press, New York

First Edition

Text © 1989 by Edward J. Sullivan
Illustrations © 1989 by Julio Larraz

Distributed in the United States, its territories and possessions, Canada, Mexico, and
Central and South America by Rizzoli International Publications, Inc.
Distributed in the United Kingdom, Eire, Europe, Israel, and the Middle East by
Phaidon Press Limited.
Distributed in Japan by Yohan (Western Publications Distribution Agency).

Editor and Publisher: Paul Anbinder

Copy Editor: Karen Siatris

Indexer: Karla J. Knight

Designer: Susan Evans

Composition: U.S. Lithograph, typographers

Manufactured in Japan by Toppan Printing Company

Frontispiece: *Mary Celeste,* 1984, oil on canvas,
60 × 70½ inches, private collection

Library of Congress Cataloguing-in-Publication Data

Sullivan, Edward J.
 Julio Larraz / Edward J. Sullivan.—1st ed.
 p. cm.
 Bibliography: p.
 Includes index.
 ISBN 1-55595-028-0
 1. Larraz, Julio—Criticism and interpretation. I. Title.
ND237.L278S85 1989
759.13—dc20

LC 89-83698
CIP

Contents

Plates

Colorplates are indicated
by an asterisk (*)

Acknowledgments

The author wishes to express his gratitude to Julio Larraz for his kindness and generosity and to Nohra Haime, Pilar Botero, Ron Hall, Carmen Melián, and Charles W. Yeiser for their graciousness and help during the writing of this text.

Except where noted, all quotations are from interviews conducted by Edward J. Sullivan with Julio Larraz in Grandview, New York, and Miami, Florida, in summer 1988.

The Main Attraction at the Circo Miguelito—The Cannonball Man, 1988
oil on canvas, 68¼ × 83 inches
Private collection

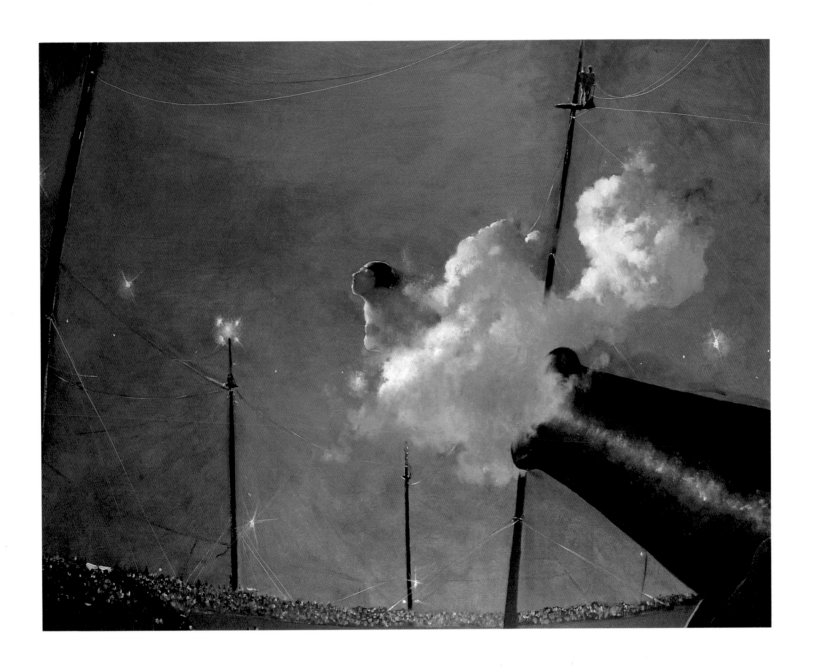

Themes and Variations in the Art of Julio Larraz

The art of Julio Larraz leaves its viewers in a state of disequilibrium. Although it may seem straightforward at first glance, his work challenges us with multiple layers of reference, subtle humor, and, at times, biting satire.

In simplistic terms, one could call Larraz a realist. With the exception of a few of his earliest pictures, recognizable imagery is at the heart of his work. Yet his art goes so far beyond mere verisimilitude that the label "realism" seems an uncomfortable word to use in defining it. Larraz is an astute observer of the contemporary art scene and is fully aware of its concerns, methods of vision, and strategies. Yet he is not a pupil of any of the specific tendencies or persuasions that are common or fashionable in the 1980s. Although all of the paintings, drawings, watercolors, prints, and monotypes of Larraz have an unmistakably contemporary feeling to them, there is always an air of the past, a hint of the artist's great reverence for older traditions lurking beyond the irony and astute commentaries of his pictures. Larraz has combed the chapters of the history of art both through his numerous journeys abroad and through the pages of the books in his library. He not only understands the artistic preoccupations of his own day but has equal empathy for the concerns of the painter in times past. In his conversations, the references to artists he admires and enthusiastically studies run from Francis Bacon and Giorgio de Chirico to Pieter Bruegel the Elder, Diego Velázquez, Francisco de Zurbarán, and Francisco Goya. In fact, of all the masters to whom Larraz is most attracted, the Spanish painters of the seventeenth and eighteenth centuries are those who have most caught his attention. This is not unusual considering Larraz's background. He is from Cuba, the son of highly cultivated parents who, while he was growing up in Havana, surrounded themselves with books on Spanish art as well as other schools of painting and sculpture. The Iberian heritage played an essential part in the development of Cuban culture, and there were obviously examples of both Spanish and Spanish-influenced works of art for Larraz to look at in his youth. He never studied drawing or painting in a formal way, but in his formative years, art in the Cuban–Spanish manner nourished his earliest visual experiences.

Cuba and Cuban culture are key points in understanding Larraz. Although he has never painted a scene that is recognizably Cuban, his art contains many references, both visual and psychological, to the land he left early in his life. The physical ambience of Cuba continues to affect his work in a palpable way. He currently spends a good deal of time in southern Florida, where he paints in an atmosphere highly reminiscent of his country of origin. Larraz's art can be further understood in the wider context of a Latin American mode of expression. When asked whether or not he feels connected to the Latin American art movements, he immediately gives a positive answer. He feels that there are many characteristics that artists from the hispanophone nations of the New World have in common.

To call Larraz a Latin American artist is to apply too simple an identifying mark to him, however. His career developed, after all, exclusively in the United States, and there are many important aspects of his work that could have been nurtured only in and near New York. Any serious evaluation of Larraz's art must recognize the significance of these "American" aspects.

It was in the United States that Larraz began to create (under the name Julio Fernández) a series of caricatures that were printed in prestigious newspapers and magazines around the country. Taking much of their "feel" from the work of master caricaturists such as David Levine, Larraz's drawings never failed to capture the essential qualities of the persons whom they represented. Their subjects' personality quirks, foibles, and physical characteristics were all instinctively noted and commented upon. The artist no longer does caricatures per se, but their spirit lives on in many of his pictures—sometimes in the most unexpected ways. A still life may contain just the right combination of strange elements to remind the viewer of an absurd situation in real life, or the turn of a head of a figure in a group painted by Larraz might suggest an oblique (but no less conscious) parallel to a well-known person or event. This is not to say, however, that the art of Larraz is topical or deals only with the here and now. On the contrary, the work of this painter is concerned with fixed values and concepts that pertain to people of this as well as succeeding ages.

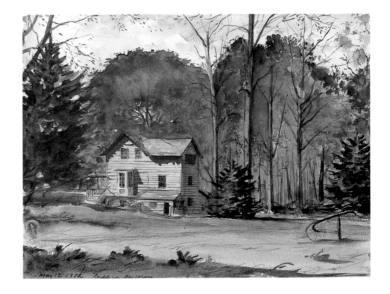

Rockleigh, New Jersey, 1972
watercolor, 9⅜ × 12¼ inches
Collection of the artist

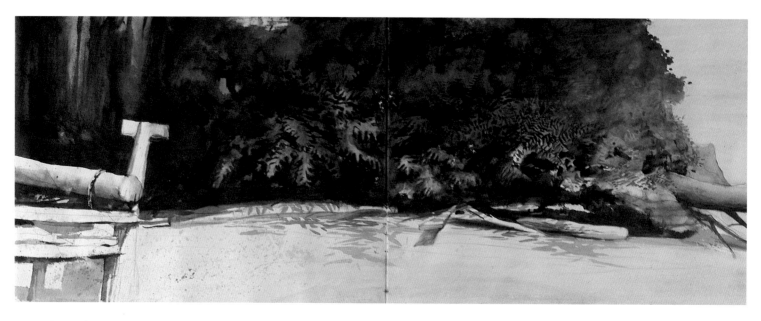

Untitled (Nyack), 1973
watercolor (diptych), 9⅜ × 24¼ inches
Collection of the artist

The art of Larraz is quite diverse in subject matter, but he is perhaps best known for his impressive still-life paintings. In these pictures, objects are usually monumentalized, made physically and psychologically larger than in real life. They take on an importance and grandeur that are often surprising and sometimes even disturbing, forcing the viewer into the realm of the surreal to find an explanation for these juxtapositions. These still lifes, which can be read as metaphors and similes, are painted mostly with strong and vibrant colors, emphasizing the power of the direct and penetrating light that Larraz remembers from his boyhood in the tropics.

There are many more categories within Larraz's art, however. Sensuous landscapes in which strong sunlight glares off the leaves of palm trees or the shimmering waters of the Gulf of Mexico complement views of a less boisterous side of nature as reflected in the subtle watercolors of the towns on the banks of the Hudson River, where Larraz has lived for many years. From time to time these landscapes contain elements that tend to add surprise or mystery—trains that move through dense jungle foliage, seemingly deserted houses that appear to rise out of nowhere, or small airplanes that hover in hidden landing strips about to embark on journeys of unknown ends.

In a sense, Larraz revives in his landscapes a tradition that was common during the Renaissance. At that time it was often considered too daring or even a breach of propriety to have the elements of nature serve as the only focal points of a painting. Trees, rivers, rocks, and sky were often not considered suitable subjects for pictures until almost the dawn of the eighteenth century. Something else had to be either present in the scene or strongly alluded to. Thus what were called "historiated landscapes" became popular. These were pictures in which the subject was, at least ostensibly, a religious, mythological, or historical event but where the artist's real intention was to show off an expertise in nature painting. Larraz often makes modern historiated landscapes in which the subject is not totally clear, and each viewer must use his or her imagination to arrive at a personal definition of the image. These pictures are fascinating in their complexity and their myriad possibilities for interpretation.

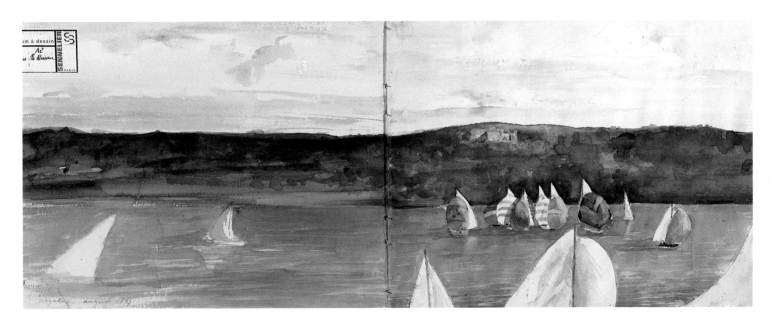

Regatta, 1973
watercolor (diptych), 9⅜ × 24¾ inches
Collection of the artist

There are fewer figure paintings by Larraz than landscapes or still lifes. He is most careful and discreet with his ambitious figure compositions, working slowly and reworking until he is able to capture exactly the essence he wishes to suggest. Here again, every element of the painting is meaningful—each glance, every bit of landscape, and even the colors of the clothing worn by the individual characters in Larraz's dramas have something to tell the viewer. Some of these figure compositions depict only one protagonist, whereas others show groups of figures. In the latter case, however, there is always one specific figure that carries the weight of the mood or atmosphere that Larraz is striving to achieve. This is so, for example, in *Crossfire* and *Le President à vie*.

Empty rooms and seemingly insignificant spaces have been important parts of the repertory of Western artists for at least a hundred years. Among the Post-Impressionists, for example, Vincent van Gogh managed to instill an aura of life (both its positive force and its angst) into rooms with no people in them. Later, Henri Matisse, painting in a very different mood, conveyed to the viewer a range of emotions tending toward the pleasant, restful, or mildly elegiac in a number of rooms with open windows. This is a device that Larraz has also used to great advantage. The scorching midday sun of the tropics often enters through his open windows. At times we are given a glimpse of a body of water beyond the confines of the room. At other times we are presented with objects on a table in the middle of a room. These objects invariably have multivalent meanings that, combined with the space around them, contribute to an unsettling or even sinister mood, as in the case of Larraz's representations of machine guns on tables in seemingly empty rooms. Sometimes the inhabitants of Larraz's secret chambers are not humans but animals. One of the animals for which the artist has particular sympathy is the monkey, and he has often painted this creature as the principal actor in his private dramas.

The following text, in conjunction with the many images of Larraz's work as it has developed throughout the past several decades, attempts to present a clear picture of this significant artist. Not a biography in the traditional sense, it does not dwell on the facts of his personal life. It does not neglect, however, some consideration of his career as it affected his art. It is, more specifically, an investigation of some of the principal themes that Larraz has developed, a study of how and where he works, and an assessment of what his art has achieved until now and the directions it may take in the future.

Larraz paints mainly in oils, and it is the discussion of this medium that predominates here. He makes numerous preparatory drawings for his paintings, many of which could be perceived as works of art in their own right, although Larraz does not consider them so. He often produces numerous watercolors in preparation for oils, and he has done an equal number of watercolors for their own sake. Watercolor is very important to the artist, and some of his most satisfying works are done in this medium. There is, naturally, a greater sense of intimacy and spontaneity in many of the watercolors than in the oils, and Larraz tackles a different range of subjects in this medium as well. It is in them that Larraz's North American roots are strongest, as they are often the products of his intense study of a number of American watercolorists such as Winslow Homer and Edward Hopper. This volume also considers several of the other media in which Larraz works, including prints and, very occasionally, sculpture.

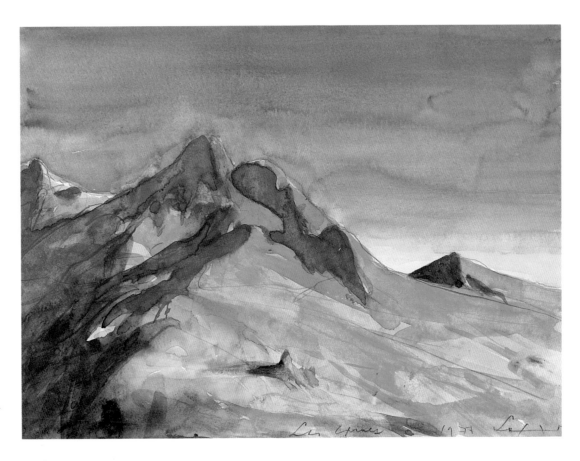

Las Cruces, 1977
watercolor, 9⅜ × 12¼ inches
Collection of the artist

North from Havana

The multifaceted career of Julio Larraz has developed in many places. Since leaving Cuba in 1961, he has lived in Miami, Washington, D.C., several small towns in Pennsylvania and New Jersey, a solitary village in the New Mexican desert, New York City, and Paris. Since the late 1970s, however, more of his work has been done in his studio in the town of Grandview, New York, on the banks of the Hudson River, than anywhere else. Larraz bought his house in Grandview in 1978 and soon added an ample studio to it. Although less than twenty miles from Manhattan, Grandview almost has the feel of a country village. In summer Larraz's house is not visible from the road, surrounded as it is by high trees and bamboo plants. During the other seasons one can see it as well as the neighboring house that has the appearance of a Tuscan villa and has often figured in his work. The quality of light in Grandview is virtually the same as that in the pictures by the Hudson River School painters of the nineteenth century, many of whom lived not far from Larraz's house. Although Larraz has painted virtually no canvases of the surrounding landscape (he has little interest in conventional picturesque views), many individual elements in his pictures are derived from the buildings, trees, and river that can be seen from the windows of his studio.

In 1987 Larraz purchased a house and a large plot of land in South Miami, and since then he has spent most of his time there. The environment in Miami is subtropical. Several varieties of palm trees grow on the land surrounding his house. Bougainvillaea and hibiscus flowers add strong accents of color to the terrain. But perhaps the most striking element of the landscape around Larraz's house and studio in Miami is the intensity of the light. Surfaces are outlined more sharply here than in the north, and the shadows are deeper, offering far greater contrasts of brightness and dark. Beginning in Miami and proceeding south toward the Florida Keys, the visitor has a greater and greater sense of the Caribbean Sea, including its air, colors, quality of sunlight, and usually humid warmth. Being in this environment provides a key to understanding so many of the themes and subtexts of Larraz's work. Spending time with Larraz in Miami, his first home in the United States, makes one consciously aware of elements in his painting that one instinctively knew were there but could never quite perceive in a palpable way. Just as the work of

Tintoretto or Titian could never be fully understood by someone who has never been to Venice, Larraz's palm trees, areas of color blanched by the sun, and black shadows are instantly comprehensible when one is familiar with the environment that produced them. Larraz's clouds, too, are often the clouds of the northern Caribbean. In no way does he ever exaggerate the scale or drama of them. On stormy afternoons in August or intensely bright mornings in November one may look to the sky and see exactly what the artist has created with oils or watercolors in his depictions of all possible cloud shapes. There is, more than anything else, an inherent integrity in these works done by Larraz in Florida. They speak of their creator's innermost thoughts in their images and in the moods that they project. This is perfectly understandable given the fact that Florida, and most specifically Miami, is the closest possible American equivalent to the artist's birthplace and emotional home, Havana. Although there are many elements in Larraz's work that connect him to artistic traditions in North America, he is, in the most profoundly fundamental ways, a Cuban artist.

Cuban art of the twentieth century is not easy to assess as a whole. At the dawn of the century, Cuba was still a Spanish colony, and the official academic cast to late-nineteenth-century Spanish painting had left a strong imprint on Cuban painters. Although the country came under the political influence of the United States after the Spanish–American War, American art traditions seem to have played a relatively minor part in the formation of the Cuban aesthetic. European modernism was the point of reference for painters such as Eduardo Abela, Marcelo Pogolotti, Carlos Enríquez, and Amelia Peláez. Of all of these, Peláez is perhaps the most interesting. A product of the Havana intelligentsia (her uncle was the famous poet Julián del Casal), she studied in Paris in the late 1920s and early 1930s, adopting in her paintings and later in her ceramic work a personal response to Cubism that incorporated elements such as the tropical vegetation of her native country and the capricious decorative forms of the beaux-arts stained glass and grillwork of nineteenth-century Havana architecture. By far the most famous of Cuban painters of the twentieth century is Wifredo Lam, who was born in Havana in 1902 to a Chinese father and a mother of African and Spanish descent. Lam was in every way an international artist.

He lived in Madrid, Paris, Haiti, New York, and Italy. Of all the many influences on his art, that of Pablo Picasso was the strongest, although the subject matter of his pictures never strayed far from the elements of the tropical atmosphere into which he was born. These often included representations of the pantheon of gods of *santería* and voodoo as practiced in Cuba and Haiti, in which aspects of Christianity and the religions of West Africa are combined in a syncretistic merger. Lam often visited Cuba and demonstrated his support for the revolutionary government of Fidel Castro. His popular esteem in Cuba remained high during his later lifetime and has continued since his death in 1982.

Although Larraz never studied the history of Cuban art in any formal way, he was aware of the important artists of his country. The oldest of three children, he was born into an upper-middle-class family in Havana on March 12, 1944. Both of his parents were interested in art and literature, and his father, who received his doctorate degrees in philosophy and political science, had one of the largest private libraries in the country. It contained several thousand volumes on painting, literature, history, philosophy, jurisprudence, and other subjects. While Larraz was never a voracious reader as a child, he would continually browse through these books. He especially liked those that contained pictures he could study and copy. Both of Larraz's parents ran *La Discusión*, one of the oldest newspapers in Havana. His mother, Emma, who had been trained as a lawyer, was in charge of administration, and his father, Julio, ran the editorial side of the daily. His liberal policies often brought severe criticism from the government. At one point in the 1930s he was imprisoned for remarks considered seditious by the regime in power. Young Julio, who according to his mother was always more interested in drawing than in any other activity, must have been particularly impressed by the caricatures published in his parents' newspaper. He was able to see them before anyone else, as he and his family lived on the top floor of the building that housed the paper in the Plaza de la Catedral in the oldest part of the city.

Larraz attended numerous schools in Havana as a child, and remembers his earliest educational experiences as not particularly happy moments in his childhood. He was distracted, was only interested in making drawings and sketches of his teachers and fellow students in his notebooks, and consequently was sent from school to school to see if he could be disciplined in the still very traditional way in effect in Cuba in the 1950s. He remembers little more than what he calls the "prisonlike atmosphere" of the boarding schools he attended. The one positive element of those years was his continued practice of caricature. His drawings became so successful that some of them were eventually published in *La Discusión*.

Although Larraz's father was politically liberal, there were so many points of contention between his ideology and that of the revolutionary government of Fidel Castro (who had been installed as prime minister of Cuba in February 1959) that the family decided to leave the island in 1961. Like thousands of others who left at that time, the members of the Larraz family were permitted to take with them only as much as they could carry. Julio's father's greatest sadness was the loss of his library. Julio himself, however, could not bear to leave Cuba without his own books. Leaving his clothing behind, he filled his suitcases with as many volumes as possible on a wide variety of subjects, from yoga to nineteenth-century literature, and departed with his family on a plane bound for Jamaica, their first stop on the journey to the United States.

As is the case with virtually anyone who left Cuba at that time (or, for that matter, anyone who has left his or her home country under duress), the emotional associations of the island are extremely powerful for Larraz. He speaks vividly of his youth in Havana, not in a sentimental way, but with a realistic understanding of the importance to him of the culture of Cuba, both in its intellectual manifestations and in its popular essence. The "spirit" of any place, country, or people is extremely difficult if not impossible to define, and those who seek to find the true nature of Cuba in its music, colors, or light understand only a very partial reality of that country. Larraz speaks of these things but also of that ineffable nature of Cuban reality as a vital component in his work—although he also stresses that his Cuban identity can help to explain his art only to a limited extent.

Larraz stayed with his family in Miami for about a year before going by himself to Washington, D.C. Meanwhile, his parents eventually went north, first to Pennsylvania and then to New York. Both became teachers of Spanish language and literature at various secondary schools and colleges in the Northeast. Julio spent most of 1964 in Martinsburg, Pennsylvania, where his father was teaching, before moving late in that same year to New York, where he ultimately rented an apartment on East Tenth Street, a street that has been home to many artists since the mid-nineteenth century. He began to paint seriously at that time. Larraz never formally studied painting either in Cuba or in the United States, but he acknowledges a debt to several artists with whom he worked during his early years in New York who taught him a great deal about painting. Perhaps the most significant of these was Burt Silverman, with whom he collaborated for several years in the late sixties. Those early years in New York were particularly difficult for Larraz. Before he was able to move into his Tenth Street studio, he worked at odd jobs (including teaching Spanish, coaching a swim team, and working in a mirror factory) and lived in rather depressing quarters. "I even lived for about a year in a windowless, airless room in the upper Nineties," the artist has said. "It didn't matter, though, that I lived this way because I was beginning to paint seriously, and I devoted all my time and energy to that, and it was enormously stimulating."

In 1969 Larraz married Scott Mills, the mother of his two children, Saskia (born 1970) and Ariel (born 1972). In the same year he moved to Rockleigh, New Jersey, where he lived for two years before moving to Upper Nyack, New York, in 1972. He would remain an almost-constant resident of the Hudson River Valley region until 1987. Larraz's first studio was a storefront in Nyack ("a very uncomfortable place with no heat, so that I would have to paint with gloves on in the winter"), close to the birthplace of Edward Hopper. Hopper's art has served as one of the many sources of inspiration for Larraz, who often evokes a similar feeling of melancholy and isolation in some of his figure paintings. In fact, in several of his works of the 1980s, Larraz painted a solitary house against a vast sky that is reminiscent of Hopper's *House by the Railroad* of 1925, which Larraz had seen in the Museum of Modern Art, New York.

Making caricatures provided Larraz with a way to earn a living for a number of years. He signed these "Julio Fernández," using his father's last name. When he began to paint he signed his works "Julio Larraz," using his mother's last name, a common practice in Spanish-speaking countries. Larraz states that among the reasons for changing his professional name was that "I thought I might have offended too many people with my caricatures, so I decided to use a name they wouldn't recognize." Larraz's caricatures were never done to offend, but, like all truly successful caricatures, they capture the unique qualities of their subjects and exaggerate them to make specific points. "My caricatures were never cartoons," Larraz has said. "They always had a serious but at the same time humorous side to them. I have been greatly affected by Goya's caricaturesque drawings, which are the most brilliant ever done." In addition, Larraz has expressed a strong admiration for the caricatures of such nineteenth-century artists as Honoré Daumier and Sir John Tenniel. "I was also interested in the type of caricatures done in nineteenth-century magazines such as *Puck*, *Punch*, and *Vanity Fair*," he has stated.[1] During the late sixties and throughout the seventies, Larraz's caricatures were published in magazines and newspapers, including *Esquire, Rolling Stone, Time*, the *Washington Post*, and the *New York Times*. Most of the caricatures published in newspapers depict political figures. Those of Golda Meir and Indira Gandhi, printed in the *New York Times* on 12 April 1970 and 3 January 1971 respectively, are simple yet brilliant summations of the physical and psychological traits of these two world leaders. In March 1972 Larraz had an exhibition of his caricatures at the New School for Social Research in Manhattan. The cover for the invitation was a striking commentary on the political conservatism and journalistic power of William F. Buckley, Jr.

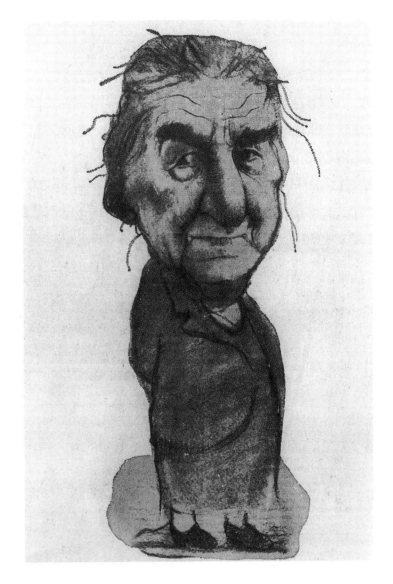

Golda Meir, 1970

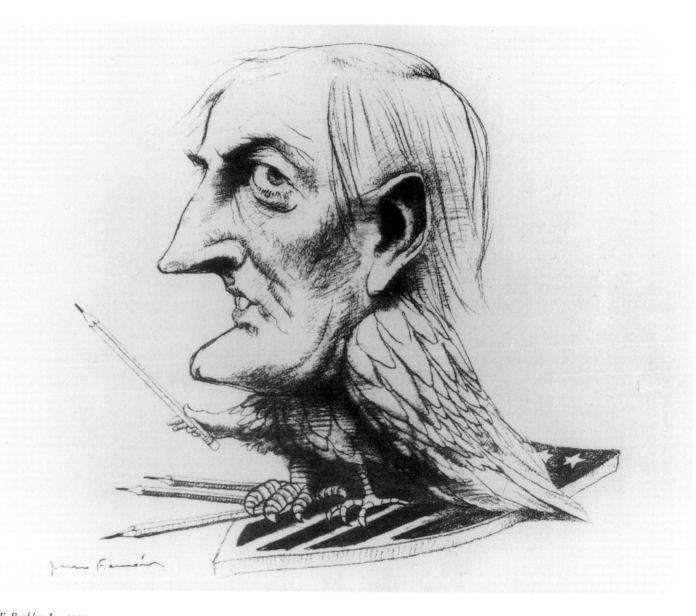

William F. Buckley, Jr., 1971

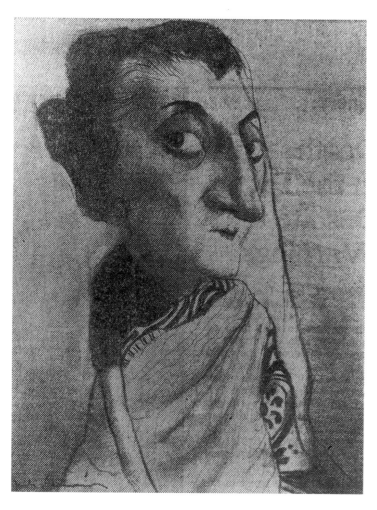

Indira Gandhi, 1971

One of the contemporary caricaturists that Larraz most admired (and with whom he established a friendship) was David Levine. Levine was instrumental in introducing Larraz to Charles W. Yeiser, owner of the FAR Gallery on Madison Avenue, where Larraz would have the first New York show of his paintings and drawings in 1974. (Before the New School exhibition of caricatures, he had already had a show in 1971 of work done since he had begun painting in 1967 at the Pyramid Galleries of Washington, D.C.) Composed primarily of still lifes, the show at the FAR Gallery took place in December and was very successful. Yeiser and the artist became friends, and their relationship was important for both of them. Yeiser recalls: "As I was also a neighbor of Julio's in Nyack, he would call me sometimes at midnight or one in the morning all excited about having started or finished a painting and would ask if I'd come over right away and see it. I usually went, and we'd stay up for several hours talking about it."

Larraz had another exhibition at the FAR Gallery in 1977 (the year he stopped doing caricatures and devoted himself to painting full time). His next two New York shows (1979 and 1980) were at the Hirschl & Adler Galleries. In 1981 he met Nohra Haime, at whose gallery he first exhibited in 1982; he has been showing his work there since that time. An important event occurred in Larraz's career in 1976, when he was invited to compete for an Award in Art from the American Academy of Arts and Letters. He won the prize and consequently participated in the exhibition of works by new members of the academy. These included not only painters but architects, writers, and composers. Larraz sent three oils and two pastels to the May–June exhibition: *The Chairman, Horse's Skull, Pomegranates under Cover, Watermelon Slice*, and *Reclining Male Nude*, which were exhibited along with works by Alice Neel, Conrad Marca-Relli, I. M. Pei, Gregory Gillespie, Charles Gwathmey, and others. The award from the academy also permitted Larraz to make an extended trip to Italy and France. This was an enormously important journey, for he was able to study many works of art that he had previously seen only in reproduction.

In 1977–78 Larraz felt the need to leave New York and experiment with the possibilities of living in a totally different environment. "I lived for a year in a small but very beautiful adobe house on the grounds of a ranch in New Mexico owned by Peter Hurd," Larraz recalls. He lived with only the "bare essentials. I hardly had any furniture—simply a bed and my easel. This was a very important thing for me to do. It gave me a new sense of time. I would paint for hours in complete solitude. I hardly saw anyone that year. During the course of the day I'd be lost in my work. If I heard an animal or the wind blowing, I'd go to the window and just look out for the longest time—thinking and meditating—then I'd return to my painting." The ranch was on the outskirts of the village of San Patricio in Lincoln County, near the Río Hondo. Although far from Taos and the part of the state in which Georgia O'Keeffe lived and worked, the landscape was similar to that in northern New Mexico. "I didn't know O'Keeffe, but I felt a great sympathy for and understanding of her work after spending time there," says Larraz. Indeed, a number of his still lifes from this and subsequent periods incorporate elements (such as animal skulls) that recall some of the paintings of the older artist.

During his year in New Mexico Larraz met Ron Hall. This art dealer from Fort Worth, Texas, was enthusiastic about Larraz's work and eventually organized an exhibition of his paintings in his gallery. Consequently, the collectors in that city, along with many in Dallas, Midland, and other places in Texas, became fervent admirers and supporters of Larraz's art.

The solitude Larraz experienced during his time in New Mexico was an important aspect of his life and one that he has tried to preserve both during his years in Grandview and during 1983–84 when he spent fourteen months in Paris. "I have never been part of the high society that so many painters love. I rarely go to openings, and when I'm at exhibitions of my own work, I can hardly stand to hear what people have to say about my pictures." For Larraz, this sort of productive isolation results in both new themes and a refinement of his own vision of his work. His recent decision to move to Miami has, in effect, distanced him even more from the New York art world. But Larraz feels this is all to the good. Regarding his life in Florida, he has said: "I love the atmosphere, the vegetation, the flowers and the plants. They are, in so many cases, identical to those things in Cuba. My memory is refreshed by being here. You can't paint so far away from your real home. You've got to be close to it. I don't like to paint snow. I did it once and it didn't work. Miami is the threshold of the entire Caribbean. It's extremely important to me to be so close to that part of the world that is mine."

1. Camilo Calderón, "Julio Larraz," *Al Día* (Bogotá), 19 February 1984, 48.

Friday Afternoon, 1988
oil on canvas, 80 × 73¾ inches
Courtesy Nohra Haime Gallery, New York

Still Lifes

Ever since ancient times, artists have been striving for realistic representation in still-life painting. There are contemporary descriptions testifying to the significance of still life in the classical world, and there even remain a few examples of antique representations of objects, living and inert, in the media of both paint and mosaic. Among the best-known tales concerning still-life painting is one written by Pliny the Elder around 400 B.C. In it he recounts the amazing capacity of the painter Zeuxis to capture the look and feel of objects in his pictures: Zeuxis painted some grapes on a curtain in such a realistic fashion that birds came down and began pecking at them, thinking they were real. In ancient Greece, the most favored subject of still-life representations (painted on walls and wooden panels and inlaid on mosaic floors) was food. The term *xenion* (literally, a gift made to a guest) was applied to this type of art. Although virtually no Greek examples of such paintings survive, we can surmise that they were done in a highly realistic, trompe l'oeil fashion. The Roman passion for emulating Greek styles probably accounts, in part, for some of the highly realistic frescoes found in Pompeii and Herculaneum of foods (often depicted on shelves), as well as for the curious "swept floor" mosaics showing the fictive remains of a meal.

In Renaissance Italy a new vogue for still life came about in trompe l'oeil decorative painting. Artists attempted to deceive the eye on walls and other surfaces by creating open cupboard doors, shelves of books or foodstuffs, and other objects painted with such fine precision that undoubtedly many viewers were fooled into believing that what they saw was real. Later, in the seventeenth century, Flanders and Holland would become, along with Spain and to a lesser extent Italy, the centers of still-life painting in its Golden Age. In the Baroque, an era to which Larraz is especially attracted, the layers of meaning of still life became infinitely more complex. Traditional representations of fruits and flowers were now used as metaphors for the senses. New genres of still life were developed, such as the *vanitas* type, which usually included at least one depiction of a skull or skeleton in close proximity to representations of worldly goods (coins, playing cards, jewelry, etc.) to connote the swift passage of earthly life and the futility of worldly wealth and glory. This category was most highly developed in Spain.

The Magic Eye, 1982
oil on canvas, 72 × 60 inches
Private collection

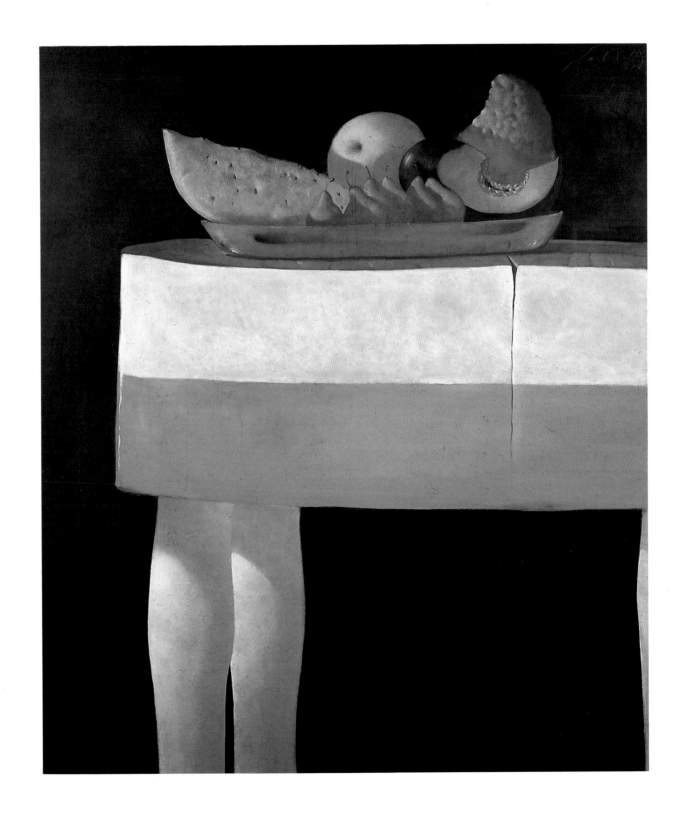

The idea of the passing nature of worldly existence was in close accord with Spanish Counter-Reformation theology and was also promoted in the writings of leading novelists and playwrights of the day, such as Calderón de la Barca. The Spanish tradition in still life (which also included more conventional representations of fruits, flowers, and other objects) continued well into the eighteenth and nineteenth centuries, with artists such as Luis de Meléndez and Francisco Goya among its outstanding practitioners.

Julio Larraz has done some of his most important work in the field of still life and has benefited from the stimulus of the Spanish tradition more than any other. A great deal has been written about the so-called mystical nature of Spanish still-life painting. Works by Juan Sánchez Cotán, Juan van der Hamen, Francisco de Zurbarán, and others have been interpreted as full of hidden meanings. Although the specific religious connotations of the works of these masters are still disputed, it is certainly true that there is more in their pictures than what a superficial glance might perceive.

Larraz never looks at anything without close examination. Through both his travels and his readings, he has penetrated the mysteries of the Spanish masters of still life, absorbed the complicated lessons of their art, and reinterpreted their aesthetic and poetic vision in late-twentieth-century terms. His still lifes reflect the range of styles of still-life painting in the history of art, but more importantly, they simply express his delight in the surprising and beautiful things of nature. We can always enjoy these paintings on a sensual level, reveling in their colors and forms as well as in their suggestions of tactile and olfactory pleasures. Larraz's *Dogwood* (1975) is an example of the type of "pure painting" that seems to defy attempts at allegorical analysis.

Although many of the still lifes contain more elements than *Dogwood*, they never seem cluttered or overly dramatic. Larraz's paintings represent the essence of subtlety. Their statements are not blatant or didactic. We are introduced to his (often complex) ideas by fairly straightforward images. Apart from its inherent simplicity, *Dogwood* exemplifies another characteristic of many of Larraz's scenes: his placement of the objects (or, in more complicated compositions, the most significant objects) somewhat off center. Here the

large glass vase with its branch of numerous white flowers is placed slightly to the right, dramatically set off by a deep black background. The whites and creams of the tablecloth also stand out starkly against the darkness, but there is nothing the least bit sinister in this representation. The flowers catch our attention and seem to suggest optimism or triumph against the blackness—perhaps this composition could even be read as a metaphor for day triumphing over night. The choice of elements is both highly interesting and subtly ironic. Dogwood flowers are inevitably associated with springtime and the coming of warmer weather after a cold winter. Larraz has also included another plant, the jack-o'-lantern, whose small orange flowers punctuate the lower part of the arrangement. It is typical of the dried plants of autumn. The artist's juxtaposition of the dogwood and the jack-o'-lantern contrasts the two intermediary seasons of spring and fall, the periods that separate the two seasons of extreme heat and cold.

Historically speaking, flowers provided one of the earliest subjects for the masters of still-life painting. Perhaps the first surviving example is a basket of roses, tulips, and other flowers from a Roman mosaic floor dated to the second century A.D. and now in the Vatican Museum. In later years Jan Brueghel the Elder, Jacques Linard, and numerous followers of Caravaggio represented the genre in Flanders, France, and Italy. As is often the case, however, the works of Larraz seem most closely linked to the Spanish tradition. Although the beginnings of the Golden Age did not witness the rise of many flower painters in Spain, the late Baroque period (i.e., after about 1660) saw the development of a number of such masters. Outstanding among these were Bartolomé Pérez and Juan de Arellano. Unlike the flower painters of Baroque Holland, Flanders, or France, these Spaniards produced simple, uncomplicated works. Although they often depicted a plethora of flowers, they did not include other extraneous elements to distract the viewer's attention from the essential components of the picture. This is Larraz's approach as well. His compositions are most often bold, with relatively few dominant images. This is true whether the work in question is a still life, a landscape, or a figure piece.

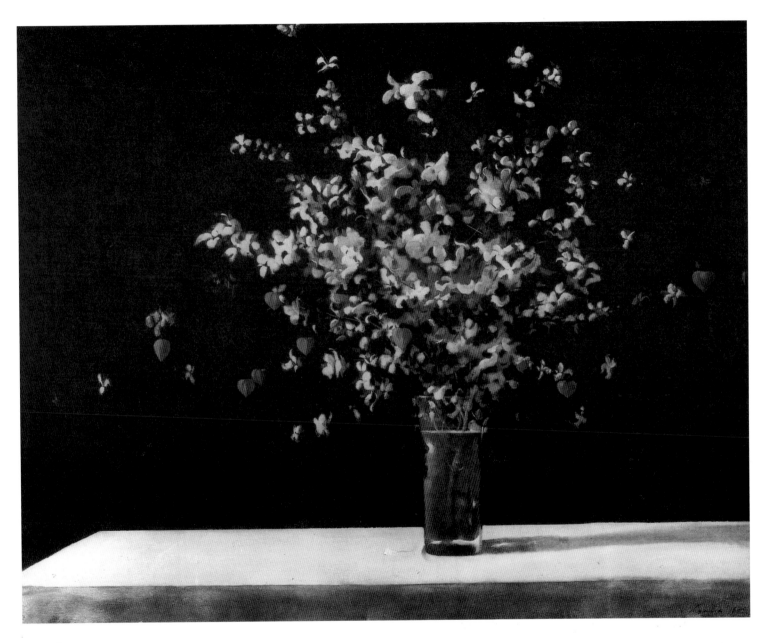

Dogwood, 1975
oil on canvas, 60 × 72 inches
Private collection

The 1984 canvas *Flowers for a Wedding* is representative of Larraz's flower pieces of the 1980s, in which sensuous warmth and an implied human presence become integral parts of the scene. Here we see many tulips of all varieties and colors, from pure white to yellow, pink, red, and deep purple. With them are a few daisies for contrast. They are placed in a large, old-fashioned marble sink that has been filled almost to overflowing with water from a faucet that still gently drips. The room in which the sink is located is typical of Larraz's rooms, a thick-walled structure with a window facing the sea. It is drenched in sunlight that almost washes out the already-faded yellow of the walls and makes the blue as diaphanous as that of the water seen beyond. This is an almost joyous image with its concentration upon color in the flowers and vivid sunlight pouring through the window. The principal element is relegated to the lower-right-hand corner of the canvas, making our eyes wander over the vast field of the room's yellow-white color. This area appears as an abstraction of space, and, in effect, it is an adaptation, in a representational context, of the color-field approach to painting (conversely, many works by color-field painters such as Jules Olitski, Ellsworth Kelly, and Mark Rothko have at times been interpreted as landscapes). In this and many other paintings, Larraz has skillfully introduced a note of tension into the scene by implying an aura of human presence in a room in which there is no one physically there. The faucet is dripping. Someone has just turned it off—but not completely. The sink is nearly full. Someone must come in and turn off the faucet so that the water will not overflow, taking with it the flowers themselves. This tension is mitigated, however, by the sunlight, which lends a carefree air to the scene. *Flowers for a Wedding* is the end result of several earlier paintings on a similar theme. Two of these, *The Poet* and *Flown from Holland* (both painted in 1983), depict metal containers full of tulips. Of these, *Flown from Holland* is more fanciful and poetic. It depicts the flowers resting on a cart that flies through the air, into the clouds and over a blue sea. *Flowers for a Wedding* complicates and enriches the scene, adding both an architectonic structure and the implied human presence.

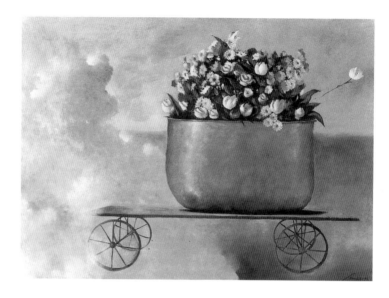

Flown from Holland, 1983
oil on canvas, 61 × 82 inches
Guest Quarters, Orlando, Florida

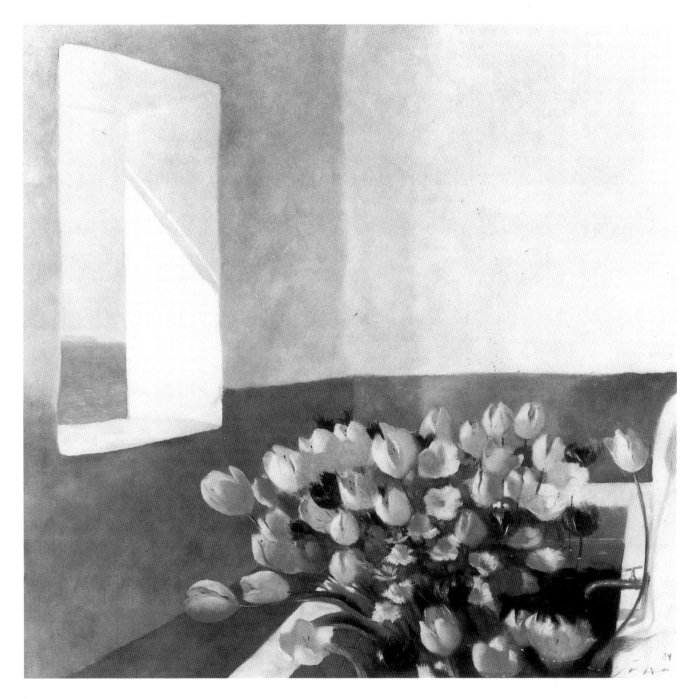

Flowers for a Wedding, 1984
oil on canvas, 50⅛ × 49 inches
Private collection

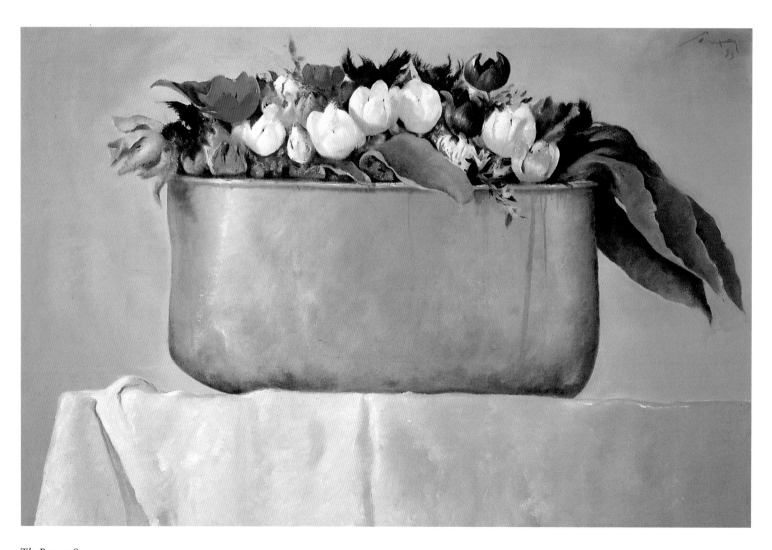

The Poet, 1983
oil on canvas, 48 × 70 inches
Private collection

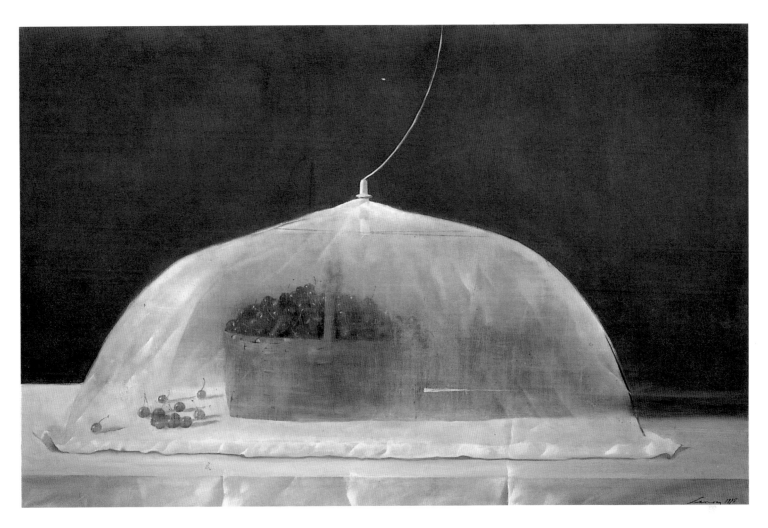

Basket of Cherries, 1975
oil on canvas, 48 × 72 inches
Private collection

Although the majority of Larraz's works are sharp and in focus, certain of his still lifes display a tendency to experiment with a hazy sfumato atmosphere that softens and envelops the elements of the composition in a cocoon of light. It is significant that this experimentation should happen in Larraz's still-life paintings, for it is here that the artist feels himself totally at ease and free to modify his standard way of approaching a canvas. Two such instances are to be found in paintings of the 1970s: *Carrots* and *Basket of Cherries*. Both are painted in oil on canvas. In the former, the rich orange carrots look more like a sculpture on the table than an agglomeration of vegetables. Larraz has positioned the carrots so that they seem to collide with one another, blending their forms into one mountainous mass (indeed, the picture has an almost geological feel to it) topped by the green leaves of the plants. These serve as a tender covering for the turbulent forms beneath. The leaves are curled; they are beginning to wilt as life ebbs away from them. This effect dimly recalls the brilliantly etched dead leaves in the only known still life by Caravaggio, the extraordinary *Basket of Fruit* painted in the 1590s (fig. 1). Larraz manipulates light here in a somewhat similar way. It enters from the viewer's space, strongly illuminating some of the carrots in the foreground and then filtering off to the sides, casting many of the interstices and the upper portion of the composition into deep shadow.

The objects displayed on the tabletop in the Caravaggio, as well as in Larraz's painting, immediately call to mind the great tour de force by Zurbarán, *Still Life with Lemons, Oranges, and a Rose*, signed and dated 1633 (fig. 2), except for the extraordinary background hanging that Larraz has included. One of the characteristics of Spanish Golden Age still-life paintings is the almost sacramental placement of the objects. Each one is treated as if it had its own personality and its own importance. This is often achieved by separating the objects from one another. In Larraz's example, most of the oranges are in a basket, but three of them are placed on a table or shelf far from each other, compositionally balancing the picture. The hanging, which can be read as a carpet or a tapestry, dominates two thirds of the composition. It is painted in rich tones of red and orange. Obviously of Indian or Persian origin, it serves as a foil for the simple fruits below and recalls the inclusion of this sort of textile in countless Dutch still

lifes of the seventeenth century. Pictures by such Netherlandish masters as Jan Davidsz. de Heem or Willem Claesz. Heda, with their luxuriant profusion of elements including gold and silver plates, elegant glassware, and rare foodstuffs, were reminders of the prosperity of Holland in the Baroque age. The use of oriental tapestries by these and other painters (including Jan Vermeer) also served to signify Holland's overseas possessions and trading partners and further represented the wealth of the prosperous bourgeoisie who commissioned them. In Larraz's pictures the iconographic meaning is by no means so specific. Here the wall hangings merely add an element of luxury to the scene and intensify, with their deep colors, the vibrant tones of the fruits.

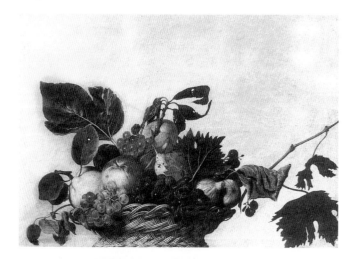

Figure 1. Caravaggio (Italian, 1571–1610), *Basket of Fruit*, 1590s, oil on canvas. Pinacoteca Ambrosiana, Milan. (Photo: Alinari/Art Resource)

Figure 2. Francisco de Zurbarán (Spanish, 1598–1664), *Still Life with Lemons, Oranges, and a Rose*, 1633, oil on canvas. The Norton Simon Foundation, Pasadena.

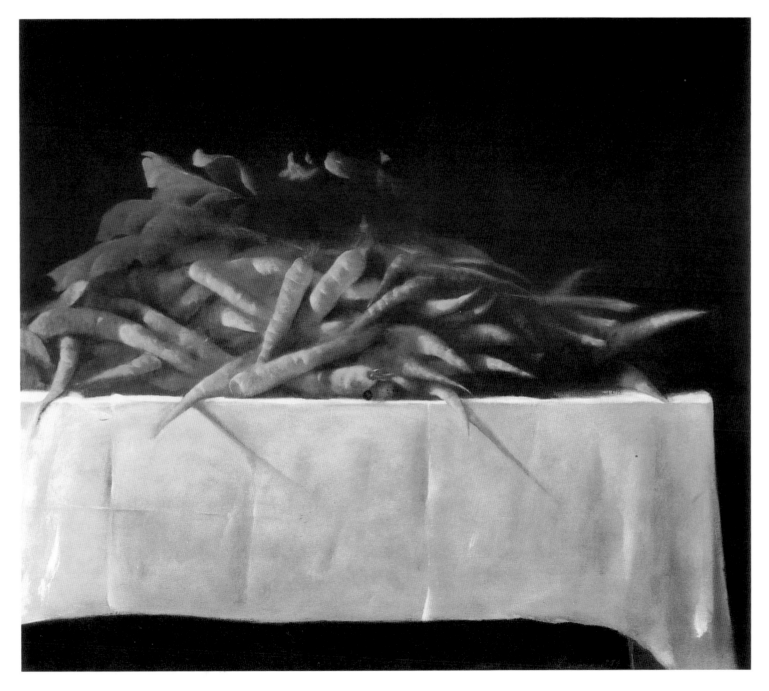

Carrots, 1974
oil on canvas, 48 × 54 inches
Private collection

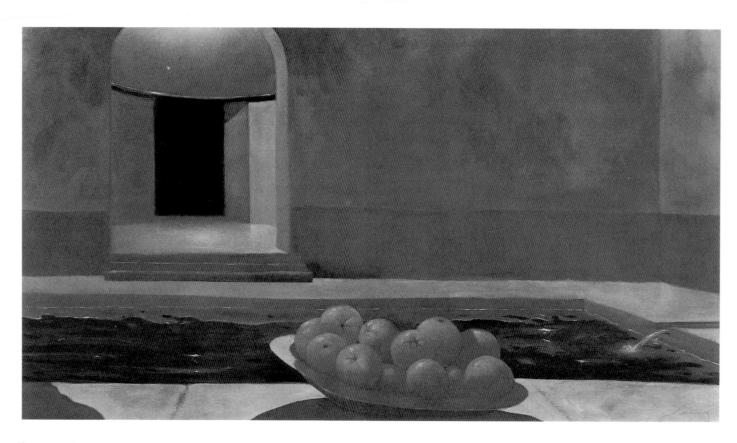

Oranges, 1980
oil on canvas, 40 × 72¼ inches
Private collection

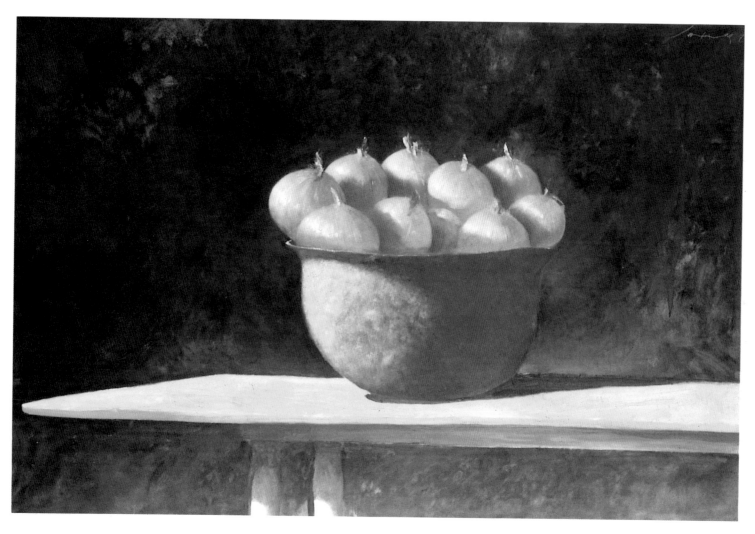

Artemis, 1985
oil on canvas, 49½ × 72 inches
Private collection

Another fruit painted with great enthusiasm by Larraz is the watermelon. The deep reds and pinks of their interiors and the variegated green shades of their exteriors can stand as symbols of warm weather and languorous afternoons. Many Latin American artists of the twentieth century employ watermelons (*sandías*) as a symbol of their continent and culture. In Colombia, for example, Fernando Botero and Ana Mercedes Hoyos have created important canvases using this fruit as a major element. In Botero's case, the still lifes with watermelons are directly or indirectly based on Spanish Baroque prototypes. In Mexico, the number of artists who have employed the watermelon as a signature element is astounding. From the 1930s through the 1950s, Diego Rivera painted striking canvases dedicated either wholly or in part to sensuous portrayals of watermelons. Frida Kahlo and Olga Costa have also contributed outstanding works to this tradition. Of all Mexican artists, however, none has so assiduously developed what we might call the iconography of the watermelon as Rufino Tamayo. Since the 1920s he has studied its varied shapes and colors with enthusiasm and sensitivity, transcending and transforming its mundane meaning. This is precisely what Larraz has accomplished in his numerous renditions of the *sandía*. In both oils and pastels, he has investigated, analyzed, and re-created every nuance of this fruit. Larraz's espousal of the watermelon goes beyond a mere statement of his Latin identity, however. He exploits the form in his pictures for its strong physicality and bulky mass.

In *The Butcher Block* of 1974, the vantage point of the viewer is from slightly below the wooden table. The watermelon has been cut into two almost equal halves by a sharp knife that lies at its side. The nicks and cuts on the board itself remind us that many things have been chopped or denatured on this table. The watermelon, however, retains a sense of inherent dignity and stability. As in some of the earliest Spanish still-life paintings, the melon seems almost to be a sacrificial element on an altar. *Blue Platter* of 1975, however, presents a more elegant and refined image of the watermelon, now cut lengthwise and placed on a white china dish painted with a delicate leaf pattern in light blue colors. In the same year, Larraz executed one of the earliest still lifes in which the natural elements take on the suggestion of other things. *Collision Course* is an oil in which a large watermelon, each

idiosyncratic irregularity in its surface lovingly portrayed, is juxtaposed with a much smaller slice of the same fruit. Although the artist maintains that his titles are merely mnemonic devices and do not necessarily refer to inherent qualities of the pictures or even to hidden meanings, one cannot escape the associations that these titles suggest. Here the viewer can almost imagine a minor catastrophe resulting from a clash between a titan and a much smaller creature. A similar sense of fantasy is evoked in a 1976 pastel entitled *Flotilla*, in which four wedges of watermelon "navigate" atop a white tablecloth against a pale blue sky. Perhaps they are merely slices of melon on a table, but it is difficult to ignore their resemblance to battleships (children's toys or the real things?) afloat on a sea. We also cannot rule out an even more literal interpretation that touches on the realities of politics and social statement. Is it not possible, after all, to read these objects as symbols for inertia or lack of potential of the navy's (whose navy's?) ships? This is not so implausible. After all, there are precedents for this in the history of modern art, especially modern Latin American art. In fact, several critics have compared the still lifes of Larraz to those of the contemporary Brazilian painter Antonio Henrique Amaral, who creates both graphic works and paintings that have the banana as their central theme. It has recently been written of Amaral that

as the apple is identified with Cézanne, the banana and its metamorphoses are associated with . . . Amaral. . . . The banana acquired a surreal air . . . through Amaral's use of close-ups, strange angles, and visual double entendres. . . . The banal object . . . becomes a symbol of humanity, both personal and national, living in the tropical reality of Brazil.[2]

The banana serves as a vehicle for serious socio-political commentary in the work of Amaral. Likewise, the watermelon is obviously a subject that means a good deal to Larraz, for it is an element that makes frequent appearances in his work as a vehicle through which he makes a variety of statements similar to those of his Brazilian contemporary.

2. H. T. Day, *Art of the Fantastic: Latin America, 1920–1987* (Indianapolis, 1987), 158.

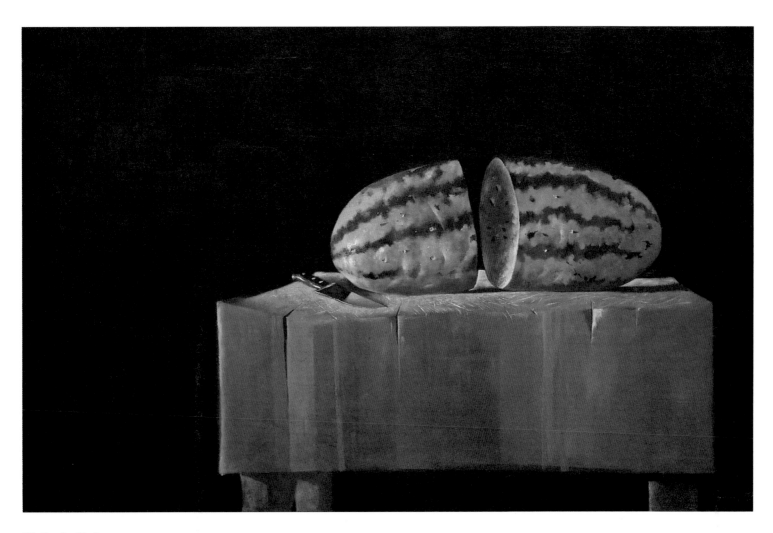

The Butcher Block, 1974
oil on canvas, 40 × 60 inches
Private collection

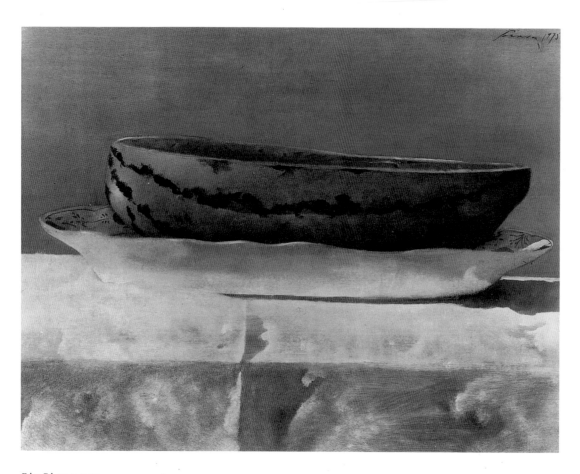

Blue Platter, 1975
oil on canvas, 24 × 30 inches
Private collection

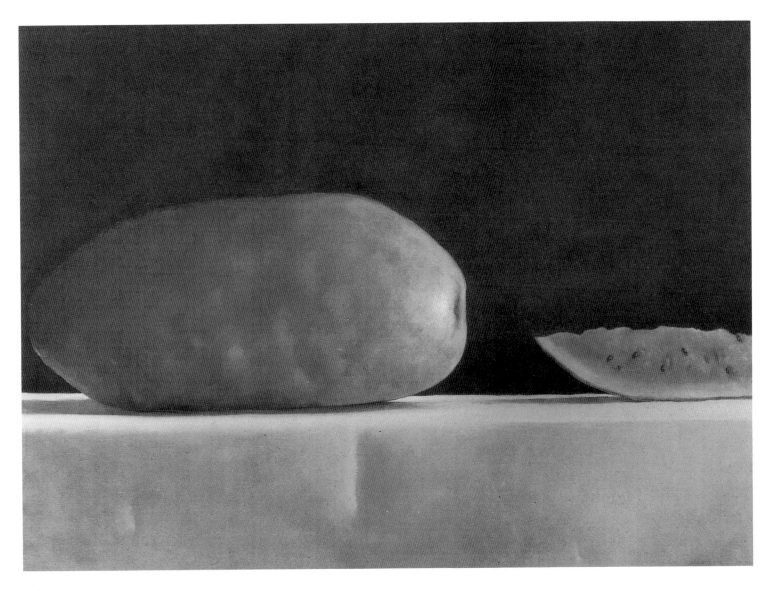

Collision Course, 1975
oil on canvas, 30 × 40 inches
Private collection

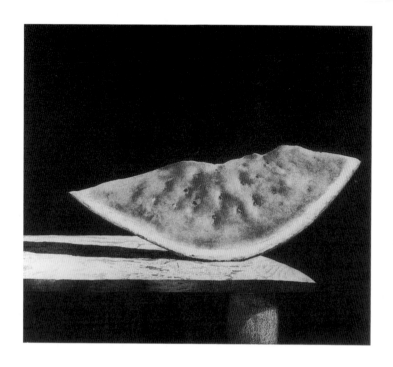 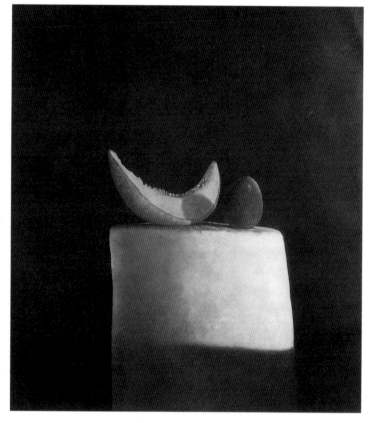

This Piece Is Mine, 1980
color aquatint, 21¾ × 23¾ inches

Eclipse, 1982
oil on canvas, 54 × 46 inches
Bacardi Corporation, Miami

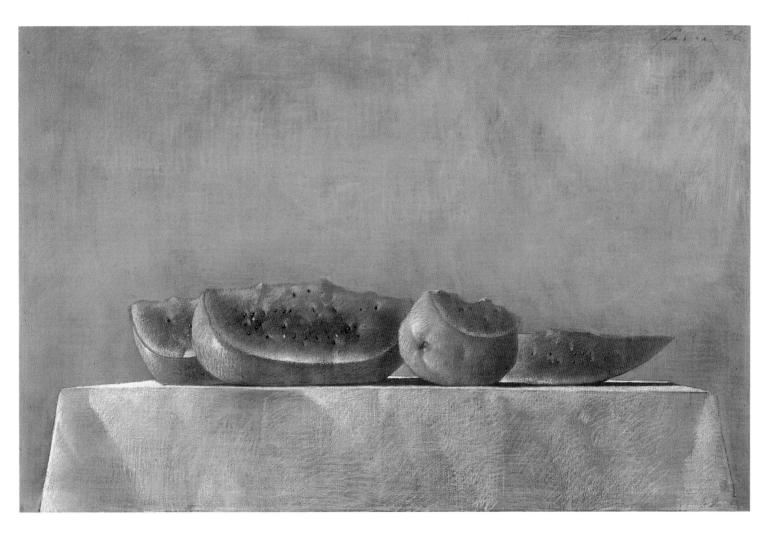

Flotilla, 1976
pastel on canvas, 48 × 72 inches
Private collection

Still life can be the least tendentious, critical, or politically charged type of painting, traditionally emphasizing pleasing textures, light, and colors. Larraz's renditions of fruits, vegetables, flowers, and other objects are often extremely pleasant to look at, but there is invariably something much more to them—at times they can even be thought of as sinister. Take, for example, the several seemingly innocuous renditions of containers of fruit in *The Language of Memory* (1983) and *Mango Boat* (1986). In the first, onions, pineapples, bananas, figs, and other fruits and vegetables (including a large white mushroom) are piled within an ample straw basket. In the second, five mangoes rest within a metal container atop a table covered with a white cloth. All is well, it seems, until one examines the picture carefully. Soon a small camera becomes visible. Its round lens echoes the shapes of some of the fruits, and its diminutive size helps to camouflage it from the other elements in the scene. The viewer may be reminded here of espionage in the tropics.

Baskets are often formidable elements in still lifes by Larraz. He has a large collection of them at his house in Grandview and often works them into his paintings. These baskets become more than merely containers. In *The Language of Memory*, the baskets become monumentalized carriers of their cargo, like armored vessels capable of moving at whatever cost through a landscape of mines and grenades.

The bizarre ambience created by the artist and his use of a given set of objects to remind us of other things, to make us dig into our subconscious memories of disquietingly unclear dreams, connect certain aspects of Larraz's art to the orthodox branch of pictorial Surrealism. In fact, the shadows here evoke Giorgio de Chirico's ability to create moods that oscillate between romantic melancholy and dreamlike dread. Larraz has expressed his strong admiration for de Chirico. He has also stated his interest in the sharply focused irrealities of Salvador Dalí. A knowledge of Larraz's attraction to Surrealism is crucial for our understanding of at least a portion of his artistic development.

The Language of Memory, 1983
oil on canvas, 74 × 72 inches
Private collection

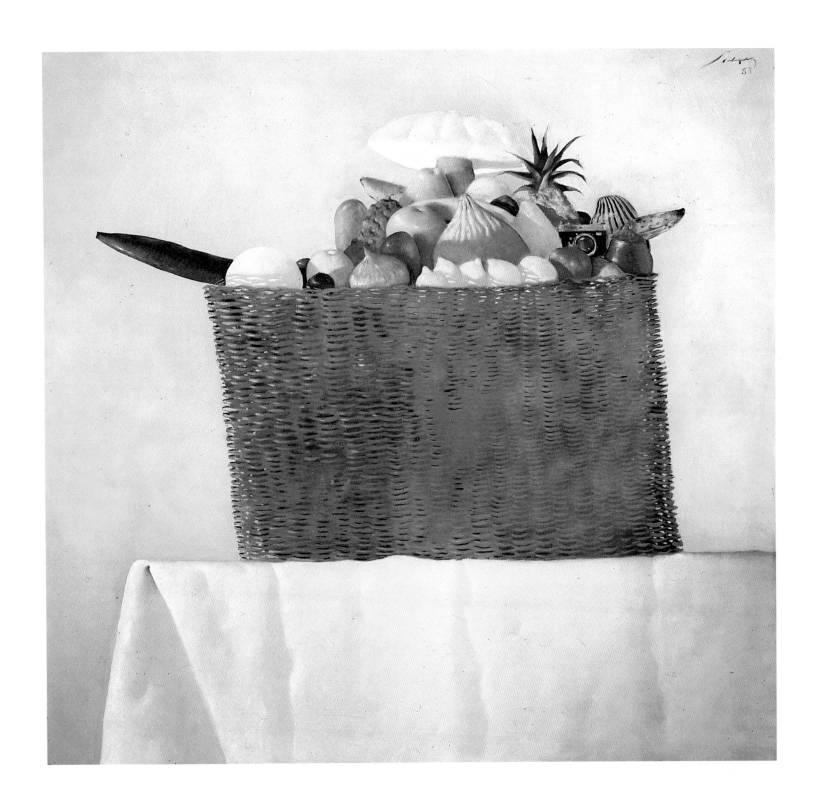

Mango Boat, 1986
pastel on paper, 19¾ × 25⅛ inches
Edward and Clarice Ellis, Los Angeles

Like de Chirico and other Surrealists such as Meret Oppenheim, René Magritte, and Max Ernst, Larraz can take the least frightening objects and endow them with a strong suggestion of dread. This has nothing to do with the fear produced by some inanimate objects in 1980s horror films in which television sets become black holes, gaping doors give access to another reality, or simple utensils become weapons of death through a misuse of telekinesis. It is more akin to the agonizingly unsettling feeling produced by a displaced recognition of objects used for purposes or ends for which we rationally know they were not intended. To put it another way, some of Larraz's canvases suggest the elements of uneasy surprise of a "chance meeting upon an operating table of a sewing machine and an umbrella," as the Comte de Lautréamont, the nineteenth-century poet cited by Ernst as the precursor of Surrealism, once wrote.

Such a painting is *Ground Control* (see p. 169), in which two mundane objects play the major roles. An old-fashioned coffeepot rests on a table covered with a white cloth. The background is painted a hazy bluish gray, reminiscent of a cloudy sky. Descending into the space is a vegetable steamer. This object appears endowed with quasi-human characteristics. Its short legs, which rest in a pot of water when the utensil is used for normal purposes, now appear as menacing spikes that will move toward the coffeepot once the object comes to rest on the table. The title obviously refers to some aspect of space travel. There is, however, somewhat more to this painting than meets the eye. While the viewer may logically draw conclusions about the meaning of this still life by referring to images of intergalactic journeys and extra-terrestrial beings, those more sensitive to the traditions of still-life painting will know that this is not all that is intended here. Larraz is playing with weights and balances, with mass and void, with objects of unequal bulk. The juxtaposition of the heavy coffeepot and the almost weightless vegetable steamer recalls one of the most important still-life paintings in the Spanish Baroque tradition, Juan Sánchez Cotán's *Quince, Cabbage, Melon, and Cucumber* (fig. 3), in which several fruits are suspended by strings at the left side of the painting, balancing the composition and lending it an added spatial interest.

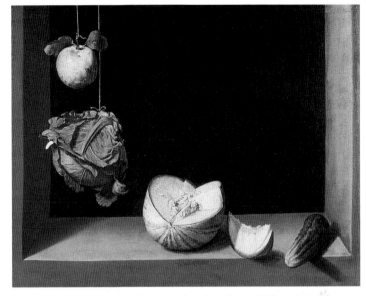

Figure 3. Juan Sánchez Cotán (Spanish, 1560–1627), *Quince, Cabbage, Melon, and Cucumber*, c. 1602, oil on canvas. San Diego Museum of Art, Gift of Anne R. and Amy Putnam, 1945.

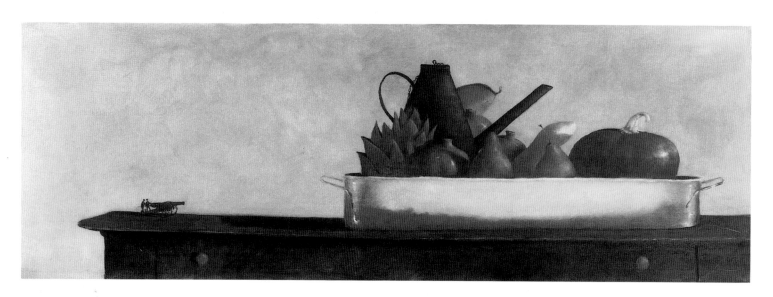

Retreat, 1983
oil on canvas, 25½ × 70 inches
Private collection

The Spy Ship, 1980
oil on canvas, 71¾ × 71¾ inches
Private collection

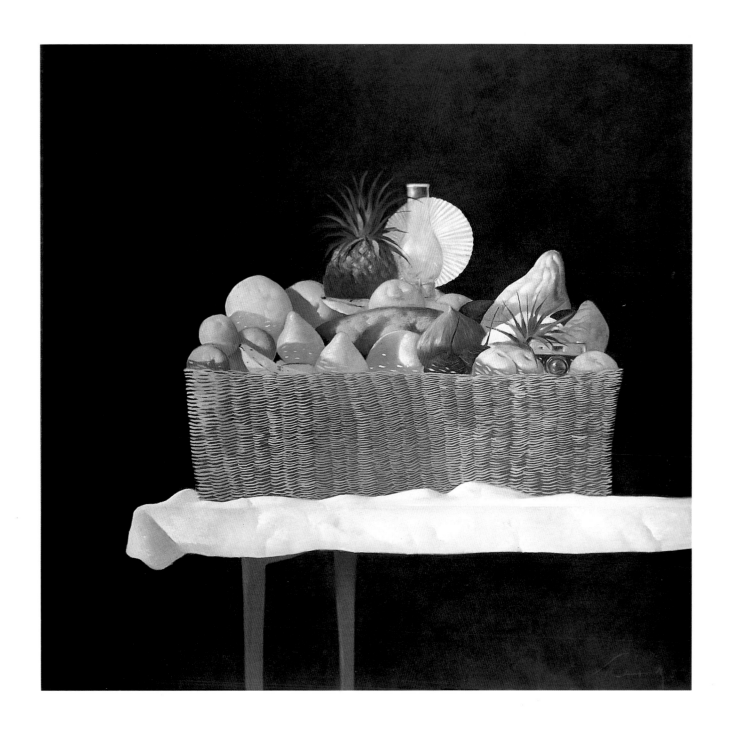

The Coven of 1980 is one of the few still lifes in which the artist has used color in a deliberately dramatic way. The bright yellow is nothing short of shocking. It resonates with an unaccustomed brilliance, contrasting with the strong white of the tablecloth. On the cloth rests a silver bowl in which there are a number of black radishes whose roots, pointing upward, add a malevolent note to the scene. Although this painting seems straightforwardly representational at first glance, there is an unreal mood created by both the searing yellow and the shiny reflection on the silver container. The otherworldliness of this picture, especially in the artist's use of heightened tones, again recalls the work of Dalí, especially his paintings of the 1930s, which Larraz refers to as the Spanish artist's "classic" period. Larraz has never approximated the full-blown Surrealism of Dalí. Instead, he has demonstrated a subtle absorption of the absurdist logic of the older artist.

In many Surrealist paintings there is a certain implied violence directed toward inanimate objects. This is often true in works by Ernst and Magritte, and it appears from time to time in Larraz's work as well. *Overture* of 1980 is one such surprising and disturbing image. An abundant basket of apples and eggplants rests on an elegant white marble table, which in turn rests on a white marble floor. This manifestation of conspicuous consumption is abruptly interrupted by an arrow that shatters the apple at the apex of the group. Questions about the origin of this arrow are useless and frustrating. Is it a modern-day retelling of the William Tell legend, or is it the revenge of a band of primitivistic fanatics against the self-satisfied *haute bourgeoisie?* We can never know —but we are never supposed to know. Such mysteries are an integral part of many of Larraz's works, be they still lifes, landscapes, or figure compositions. This puzzling element is one of the enigmatic hallmarks of Larraz's oeuvre.

The Coven, 1980
oil on canvas, 72 × 60 inches
Collection of the artist

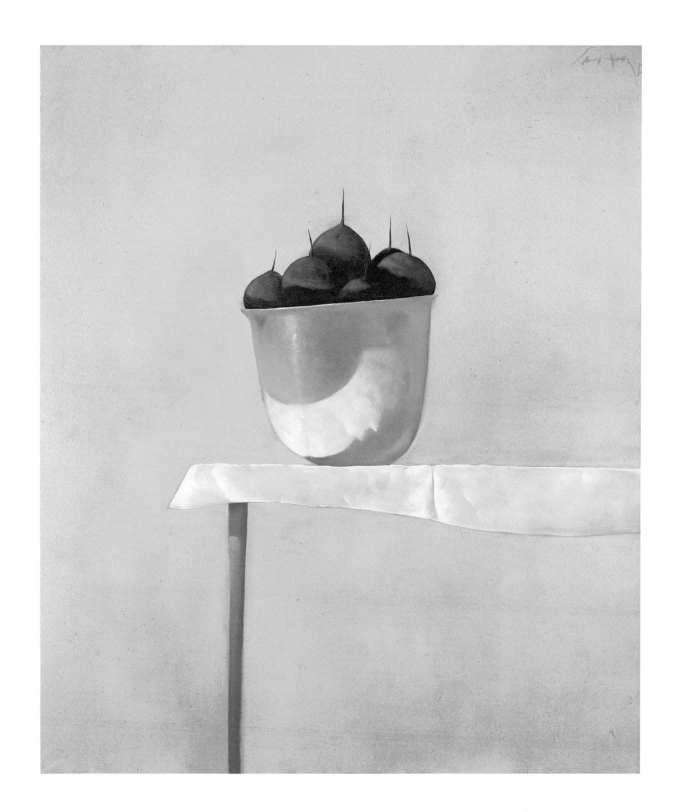

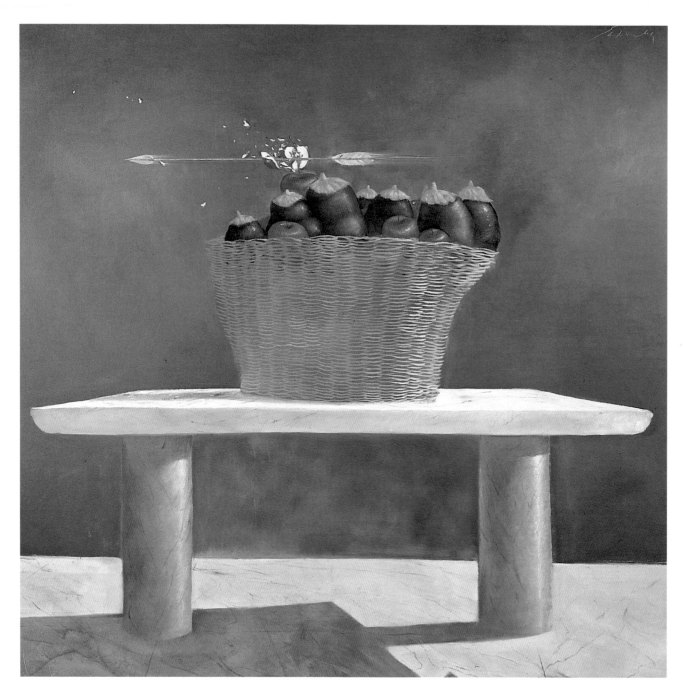

Overture, 1980
oil on canvas, 72 × 72 inches
Mr. and Mrs. Michael C. Brooks, New York

Total Eclipse, 1983
oil on canvas, 84 × 84 inches
Private collection

One of Larraz's most compelling real–unreal still lifes is the 1985 *Monument*. At first glance this oil resembles many of his other, more conventional pictures portraying pots, bowls, and vases of fruits, flowers, and vegetables on a shelf or table. On a window ledge is large bowl of ripe tropical fruits including bananas, oranges, limes, and lemons; beyond is a view of a calm, blue sea. Only when we look more closely does the picture reveal itself as a fantasy, a dreamlike reverie produced by the scintillating heat of a summer's day. The bowl of fruit is actually mammoth; below it are small houses, a church, and numerous people, walking, standing in groups, and talking. A horse and carriage are reflected in the gleam of the silver fruit container. We the spectators immediately become Gullivers as we observe these tropical Lilliputians beneath us and experience the fantastical (and, in this case, thoroughly Latin American) sensibility of exaggeration.

Equally dramatic are two related paintings that are quite unlike anything else that Larraz has ever done, both for their intensely dramatic impact and for their heightened realism, which identify them with a distinctly Latin aesthetic. The two versions of *Hurricane*, painted in 1985 and 1987, both depict a room with a view to the exterior (in one it is through a window; in the other it is through a door). A storm has come up and the winds are blowing so strongly through these openings that the tables with their contents are upset and the lamps hanging from the ceilings swing vigorously. These scenes are fascinating testimonies to the violence of weather conditions in the tropics, but even more interestingly, they seem to suggest a key scene from one of the most brilliant books by Gabriel García Márquez, an author for whom Larraz has expressed a deep admiration. The novel, *El amor en los tiempos del cólera (Love in the Time of Cholera)*, was first published in Spanish in 1985 (the year the first of the *Hurricane* paintings was executed). It appeared in English in 1988. In the first chapter, Señora de Olivella has organized a grand luncheon party to honor her husband's twenty-fifth year as a physician. All of the most important members of the high society of the unnamed Colombian coastal town where the novel takes place are invited. The occasion is an elegant one, yet it is threatened with ruin by a sudden squall:

She had anticipated everything except that the celebration would take place on a Sunday in June when the rains were late. She realized the danger when she went to High Mass and was horrified by the humidity and saw that the sky was heavy and low and that one could not see the ocean's horizon. Despite these ominous signs, the Director of the Astronomical Observatory, whom she met at Mass, reminded her that in all the troubled history of the city, even during the cruelest winters, it never rained on Pentecost. Still, when the clocks struck twelve and many of the guests were already having an aperitif outdoors, a single crash of thunder made the earth tremble, and a turbulent wind from the sea knocked over the tables and blew down the canopies, and the sky collapsed in a catastrophic downpour.[3]

In complete contrast to the chaos and pandemonium of his *Hurricane* pictures, Larraz's canvas entitled *Oranges* (see p. 34) is the essence of placidity and classical serenity. A white plate of oranges rests beside a pool in an otherwise empty room. A small jet of water continues to fill the pool and an arched doorway leads our eyes out to another space. Memories of Roman baths fill our minds as we look at this restful picture. We might imagine these oranges being served as a cooling and delicious respite after the heat of a calidarium. At any moment a patrician gentleman or lady might enter this space, perhaps that of a tepidarium, an intermediary place of pleasant temperatures, and refresh himself or herself with one of these beautifully painted fruits.

3. Gabriel García Márquez, *Love in the Time of Cholera* (New York, 1988), 34.

Monument, 1985
oil on canvas, 82¾ × 60½ inches
Tony and Leonora Blanco, Caracas, Venezuela

Hurricane, 1985
oil on canvas, 48½ × 79 inches
Private collection

54

The Hurricane, 1987
oil on canvas, 72½ × 84 inches
Courtesy Nohra Haime Gallery, New York

Indeed, the subject of bathers and bathing has a long-developed history in art, and Larraz's painting *Oranges* is not his only work that draws upon this tradition. The voluptuous canvas known as *Kurdistan* of 1981 is a high point in his development of the theme. The painting is titled for the small fragment of the oriental carpet seen at the bottom of the picture. The thick-ledged window with a view of the sea situates the scene in a tropical climate. A human presence is communicated to the viewer through the water that fills the tub. At any moment someone may come through the unseen door to step into the bath. We intuit that the bather will inevitably appear before us without clothing; thus an element of voyeurism is present. Yet we feel no shame or embarrassment, for until the bather arrives we may revel in the light-filled room and the delights of the water, experiencing a vicarious burst of pleasure while looking at this old-fashioned tub in a cool, tiled room in the tropics.

Kurdistan's link with past traditions is both obvious and obscure. Ancient and Renaissance artists frequently painted Venus and other mythological figures as bathers. The artists of the Rococo also delighted in this theme, often attaching to it highly erotic connotations. In the nineteenth century, Gustave Courbet, Edouard Manet, Edgar Degas, and many others painted bathers—now performing, more often than not, their ablutions in modern bathtubs. Rarely, however, were the tubs ever painted alone. Even in the twentieth century, when the bather theme continued to attract the attention of many artists, the human element was consistently present. One notable exception in the fairly recent history of art, however, is Pierre Bonnard's *Nude in the Bathtub* (fig. 4). In this work, a tub dominates the right side of the composition.

In the tub is the artist's wife, although only her legs and lower torso are seen. The left-hand side of the picture contains an equally cut-off view of the artist himself and, more importantly for our purposes, a coloristically rich representation of a luxuriant red and yellow carpet. The viewer's eye is drawn first to the carpet and only then to the figure in the tub. This picture was on view at the Centre Georges Pompidou in Paris from late February through May of 1984 in a large exhibition of the late work of Bonnard (there are several related paintings in public and private collections in Europe and North America). Larraz, who was living in Paris at that time, was struck by this powerful image and derived his general theme for *Kurdistan* from it. *Kurdistan* was also a product of Larraz's philosophical ruminations. About this picture he has stated: "When I was working on this painting in my studio in Paris, I was reading some of the theosophical writings of Annie Bessant. I consequently felt the need to create something that would reflect calmness and serenity, and *Kurdistan* was the result."

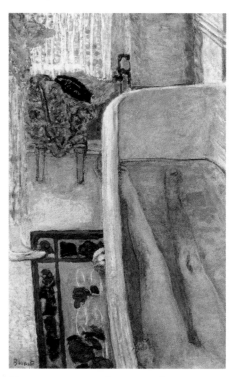

Figure 4. Pierre Bonnard (French, 1867–1947), *Nude in the Bathtub*, c. 1925, oil on canvas. Private collection, France.

Kurdistan, 1984
oil on canvas, 48 × 81 inches
Private collection

In the late 1970s Larraz executed a series of still-life paintings showing fruits and vegetables on tables covered by gauzy nettings or fruit veils to keep insects away. This series includes *Basket of Cherries* (see p. 31) and *Casabas under Cover*. The most curious of these paintings, however, is *The Edge of the Storm* of 1979 (see p. 169), in which a basket of onions and a large watering can are partly covered by a thin white net hanging from a string in the upper portion of the canvas. The soft green of the background and the diaphanous white of the cloth create an appealing contrast and serve to suggest a slight note of mystery in this otherwise straightforward scene. The protagonist in this still-life drama is the filmy cloth itself. Viewers may be reminded of the startling effects achieved in the painting of white cloth by Zurbarán and his followers in Spain during the Baroque period. They would often portray the veil of Veronica (with the face of Christ) as a large white cloth against a black or neutral background.

Casabas under Cover, 1979
oil on canvas, 50 × 60 inches
Archer M. Huntington Art Gallery,
University of Texas, Austin

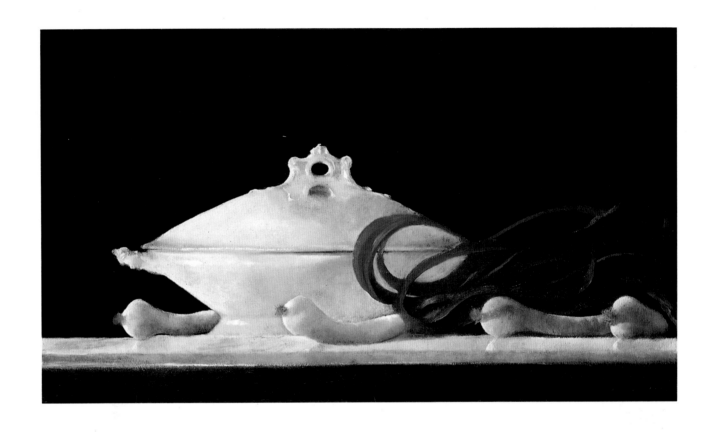

(Left) *Detail*, 1984
oil on canvas, 49½ × 57 inches
Private collection

Leeks and White Soup Tureen, 1975
oil on panel, 17¼ × 29⅜ inches
Private collection

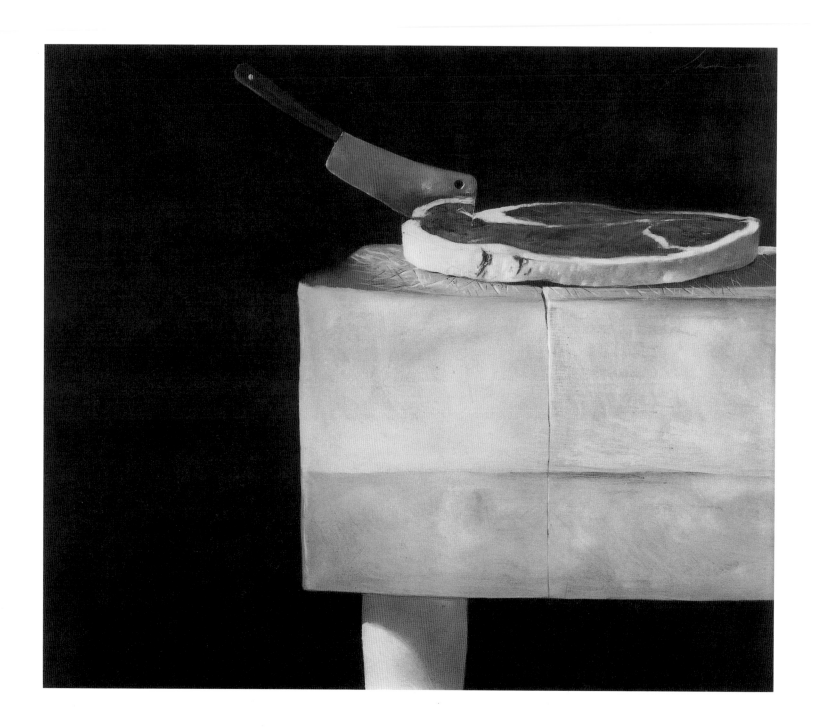

A much more concrete and direct image is present in *Steak*. This is one of a series of pictures of butcher blocks set against black backgrounds. In each one, the table and the objects on it take on an extraordinary sense of monumentality. They loom before us, becoming megalithic in their intensity, appearing as modern-day versions of Stonehenge or any of the other gigantic neolithic monuments. In the case of *Steak*, the subject matter has a much greater resonance than the simple rendition of raw meat that it appears to be. Even taken at face value, this picture contains something strong, even repellent. Aside from any natural repugnance some viewers might feel at the sight of a large piece of raw steak, there is a violent aspect here represented by the butcher's knife thrust into the substance. It is not at all farfetched to read this still life as a metaphor for pain or suffering, at least on one level (without, of course, denying its visual power and the tactile beauty of the handling of the paint). Many other artists have tackled similar themes of meat or dead animals in earlier times. Rembrandt's 1655 *Flayed Ox* (fig. 5) offers a vivid point of departure for the consideration of such a tradition. Although it could well be argued that this and other Baroque representations of dead animals were simply realistic essays in understanding animal anatomy (of which the concomitant human images were, naturally, those of the dissecting room), they can doubtlessly be interpreted on an allegorical level as well. This type of representation continued into the twentieth century; Chaim Soutine's *Dead Fowl* of 1926–27 (Art Institute of Chicago) is one famous example. Closer to Larraz's conception, however, is the sort of image that began in the eighteenth century with Spanish painters such as Meléndez, whose *Salmon Steak* of 1772 (Museo del Prado, Madrid) offers a similarly stark representation of its subject. This was followed by Goya's masterful rendition of the same theme in

Still life with Salmon executed about 1808–12 (fig. 6), in which the viewer feels the innate sympathy of the artist for his subject. While Goya's depiction gave rise to many further related pictures (including several still lifes by Manet), the Larraz composition is closest to the Goya in mood and atmosphere. Goya is another artist for whom Larraz feels a special veneration. At times this is most apparent in some of the more grotesque or even caricaturesque aspects of his work, but even in straightforward images such as this, one feels the direct inspiration of the Spanish master.

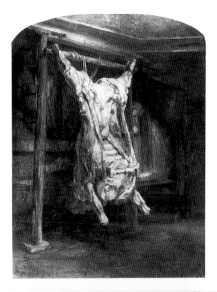

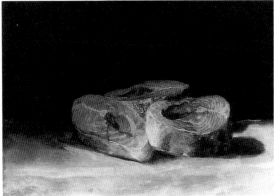

Figure 5. Rembrandt van Rijn (Dutch, 1606–1669), *Flayed Ox*, 1655, oil on canvas. Musée du Louvre, Paris.

Figure 6. Francisco Goya (Spanish, 1746–1828), *Still Life with Salmon*, c. 1808–12, oil on canvas. Oskar Reinhart Collection, Winterthur.

Steak, 1977
oil on canvas, 38 × 44 inches
Private collection

Larraz has always had an affinity for the irregular shape, the bizarre form found in nature. This may explain why he has been so attracted to large conch or clam shells and has painted them relatively often. They are also, of course, reminders of the tropical clime of his youth. The perfect juxtaposition of the complicated and the simple is present in his renditions of these forms. The 1976 oil *Giant Clam* is a good example. Here the shell becomes an abstract shape set, as usual, off-center on a white surface. It stands out against the blackness with a defiant boldness. The 1978 *Ocean Temperature*, however, is a more gentle image, harmonious—indeed, symphonic—in its skillful blending of textures and substances. The variegated white of the shell is played off the crisper white of the cloth and the wall. The window opening onto a vast expanse of sea in the background gives a direct tropical reference.

Larraz's year spent at San Patricio, New Mexico (1977–78), introduced him to a wide variety of new forms that could only be found in desert places. These elements, most notably the animal skull, would appear many times in his later paintings. Larraz, possibly taking his cue from some of the works of Georgia O'Keeffe, employs these haunting forms sometimes in an unselfconscious way, as additional elements in a still-life composition, and sometimes to evoke feelings usually associated with a darker mood. He has never used a human skull in his paintings, as older creators of memento mori pictures did, but these animal skulls at times serve a similar purpose. The 1984 oil *Buffalo* is, ultimately, a disturbing picture for several reasons. For one thing, the artist has objectified the skull, making it into the opposite of something that was (at least at one time) alive by placing it on a pedestal in an imagined museum or gallery. Then he has placed on the skull the horns that it had in life and of which it has since been stripped. The background offers complete neutrality. We are given no context other than that of "art." Yet we know that this skull was in the past a part of a vibrant, even violent creature.

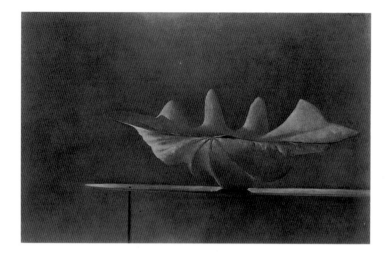

Giant Clam, 1977
oil on canvas, 42 × 60 inches
Private collection

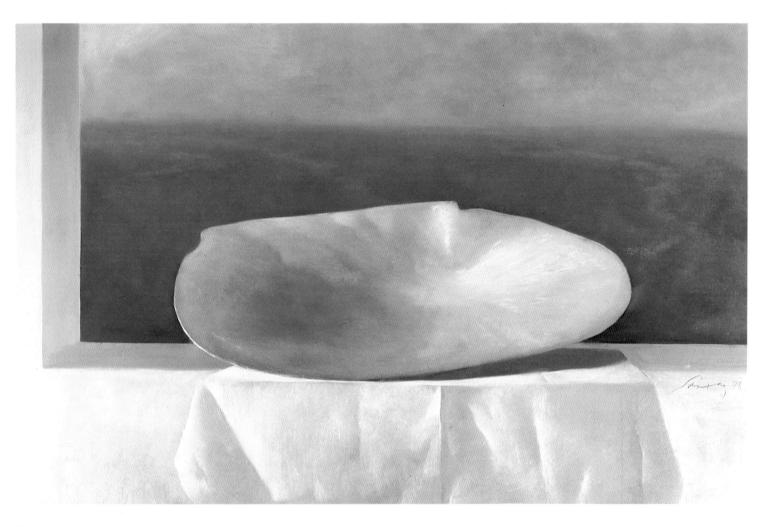

Ocean Temperature, 1978
oil on canvas, 46 × 70 inches
Walkiria Menocal, Paris

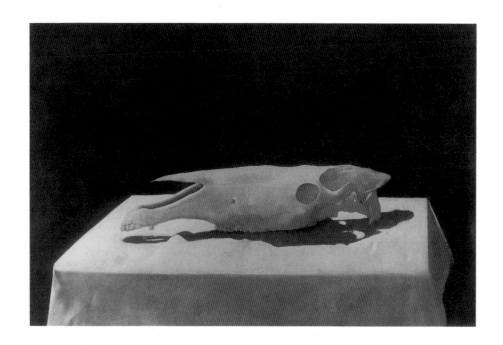

White on White, 1979
oil on canvas, 40 × 60 inches
Private collection

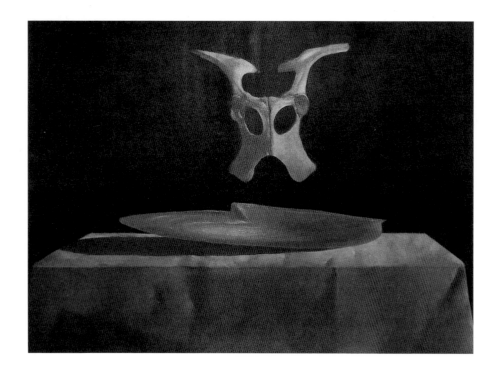

The Mask, 1978
oil on canvas, 48 × 60 inches
Private collection

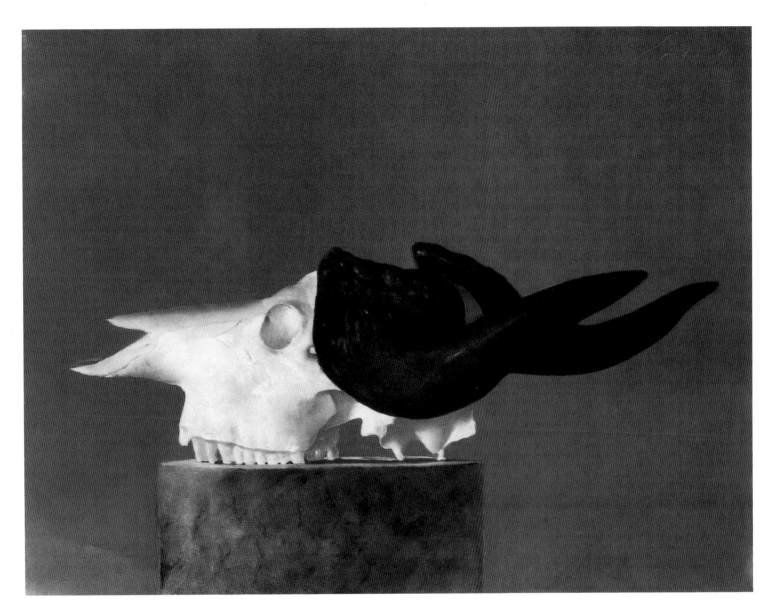

Buffalo, 1984
oil on canvas, 37 × 47 inches
Courtesy Nohra Haime Gallery, New York

Violence, or at least the implications of it, crop up in other images. Among Larraz's most curious still lifes are those that include depictions of guns. One of the earliest appearances of a gun in the artist's oeuvre was in the 1977 oil *Portrait of a Weapon*, in which an antiquated Thompson machine gun rests, quite nonchalantly, on a table amid an assemblage of pomegranates (with one on the floor). This is an enigmatic work on many levels. Pomegranates are traditional symbols of fertility in pagan iconography and of the hope of immortality and resurrection of the soul in Christian terms. These are positive, optimistic values, in contrast to the inevitable negative associations of this large metal instrument. The picture is bathed in a Caravaggesque twilight, which also gives out mixed signals to the viewer. More direct in its irony is the 1984 *Sincerely Yours*, in which a Soviet-made Kalishnikof rests on an elegant marble table, perhaps in the hallway of the house of the well-to-do individual whose portrait is partially visible above it. The natural and unconcerned way that the gun is placed is disconcerting; even more so is the pointed juxtaposition of the rifle with the lower legs of the woman in the portrait.

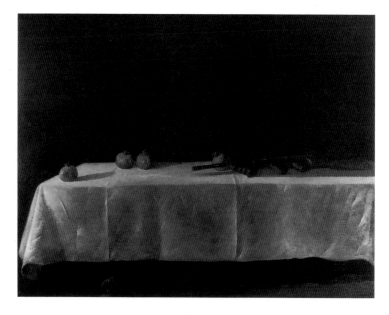

Portrait of a Weapon, 1977
oil on canvas, 54 × 66 inches
Joe Minton, Fort Worth, Texas

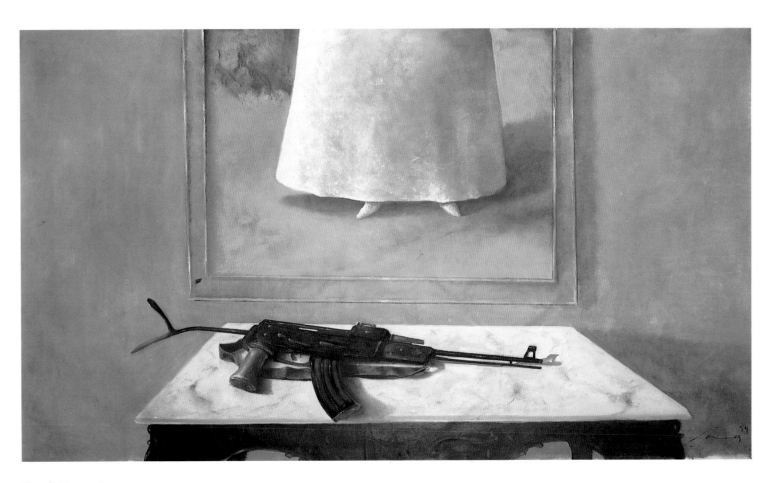

Sincerely Yours, 1984
oil on canvas, 48 × 82½ inches
Nohra Haime, New York

Larraz tells a story of his early life in Cuba that might have some bearing on these compositions with guns. He states that once when he was a very young boy, he went with his mother to visit a local political official. While she was speaking with him, Julio sat behind him. When mother and son left the office, the boy was trembling. When asked by his mother what made him so nervous, he replied that he had seen a revolver on the man's desk, which he kept handling the entire time the adults spoke. His mother answered him with surprise; she had not noticed the gun. This was because, as the artist explains, even genteel people often had guns, and no one seemed to notice or mind. When visiting each other's houses, they would politely leave their weapons on the hall table. Evidently, the choice of a powerful gun such as a Kalishnikof is representative of (and indeed an integral part of) Larraz's cathartic coming to grips with his exit and that of his family from Cuba. This weapon has been monumentalized by the artist in one of his few sculptures. The 1987 bronze *Kalishnikof* (cast in an edition of six) presents the gun by itself, devoid of any narrative context, forcing the viewer into a direct confrontation with it. It is in many ways a frightening (although still beautiful) image—even though it is made of bronze and cannot be fired, it still retains its aura of implied violence and destruction.

Although Larraz is attracted to sculpture, he has done only two pieces to date. He plans, however, to execute more in the future. Both sculptures are in bronze, and both are derived from themes that Larraz had already treated in his paintings. *Labor Day* of 1986 was cast, like *Kalishnikof*, in an edition of six. It represents a large pot with several lobsters cooking in it. Larraz has also depicted cooking lobsters in an oil painting, several drawings, and a monotype. The sculpture is enormously rich and varied in its suggestion of tactile qualities. The lobsters fairly burst from their container, claws extending over the perimeter of the pot. Although the theme and even the title are very American, the piece itself recalls more than anything else the sculptures of Degas in its three-dimensional bulk and its play of rough and smooth surfaces.

Kalishnikof, 1987
bronze, 2 × 37½ × 11⅛ inches
Courtesy Nohra Haime Gallery, New York

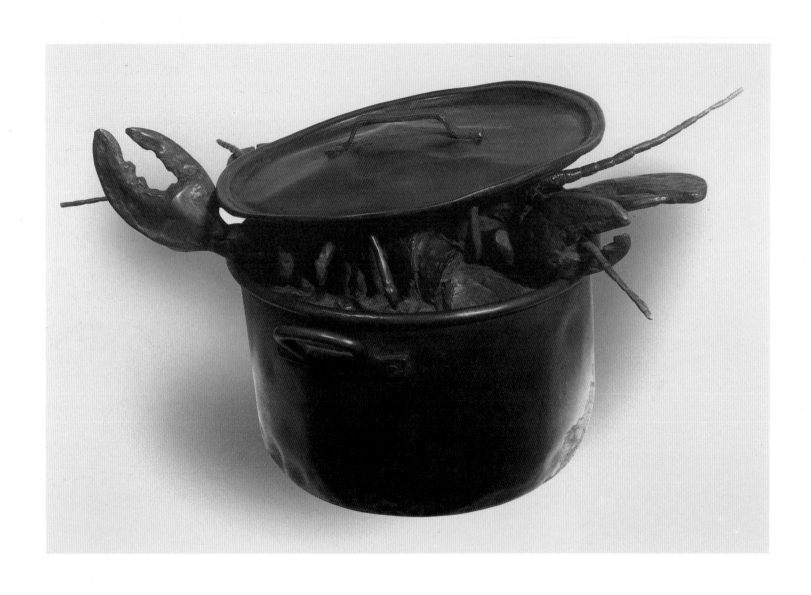

Labor Day, 1986
bronze, 17 × 30 × 21 inches
Courtesy Nohra Haime Gallery, New York

Four Lobsters in a Tub, 1984
oil on canvas, 30 × 47½ inches
Private collection

Larraz's still-life paintings are rife with references to other things and other essences outside the immediate grasp of the viewer. There is an inevitable poetic quality to so many of these pictures, and in many an entire atmosphere of light, colors, and even sounds is evoked. *A Day in Istanbul* (1984) and *Habeas Corpus* (1986) depict cellos set on wheeled carts placed on tiled floors. The instruments are perfectly still and no bow is in sight, yet the viewer is given the impression that someone will soon enter the scene and begin to play. Given this indirect human presence here and elsewhere, one can easily understand many of the still lifes as implied figure compositions. In addition, one can easily imagine that the person who might suddenly enter the scene is the artist. He insinuates himself almost physically into the work. These still lifes might thus be understood, by extension, to be paradigmatic self-portraits. Larraz has created a world for himself in each picture, and if we look at these images with careful attention, we can almost feel him standing beside us.

A Day in Istanbul, 1984
oil on canvas, 56 × 70 inches
Private collection

Habeas Corpus, 1986
oil on canvas, 66 × 83½ inches
Private collection

Figures of the Mind

In 1987 Julio Larraz executed one of his most hauntingly poetic single-figure images. Entitled *The Chart*, it depicts a rather elderly woman seated before a map. On either side of the map are open books, and the light of an oil lamp illuminates the scene. Such a simple description belies the work's power and dramatic force, which are derived from numerous details that remove this picture from the banality of the merely descriptive to the realm of a mesmerizing fantasy. We see the woman from above, with fragments of two beams separating our space from hers. Our sense of place and of space is immediately disoriented by this unexpected viewpoint and by the tilt of the lines that dominate the composition. Is the woman seated in a cell-like basement chamber or in the lower recesses of an ancient wooden ship? Our sense of time is equally distorted by the woman's costume. She is dressed in an all-enveloping gray robe and wears a tight-fitting gray skullcap, giving her the look of some ancient priestess or soothsayer from the Middle Ages. The map she reads presents something—the world?—as it may have been seen by some archaic chartmakers: a white elliptical form floating in a blue void. Indeed, we are puzzled again, for we could just as easily comprehend this map not as a geographical chart, but as some bizarre astrological pattern created by the old clairvoyant before us. We are both attracted and repelled by this scene, which is painted with a lightness of brush so as to soften all contours and increase the somnambulistic quality of the picture.

The drawing itself is somewhat indistinct and purposely blurred, heightening the disjuncture between fantasy and reality. The delineation of the woman's face is particularly haunting. Her long nose, thin eyebrows, and melancholic mouth are perfectly distinct from a distance but seem to dissolve in haze when we approach the picture. There is no story as such being told here, but, as in so many of Larraz's single- and multifigured compositions, we are presented with something that we may vaguely remember having seen in a dream. There is often a disquieting sense of déjà vu in Larraz's imagination. Yet at the same time there is often something very specific in these images. This is undoubtedly because so many of the people he paints in these guises are those he knows well or composites of several people who have meant something significant to him in his lifetime. It is essentially

The Chart, 1987
oil on canvas, 51 × 69½ inches
Collection of the artist

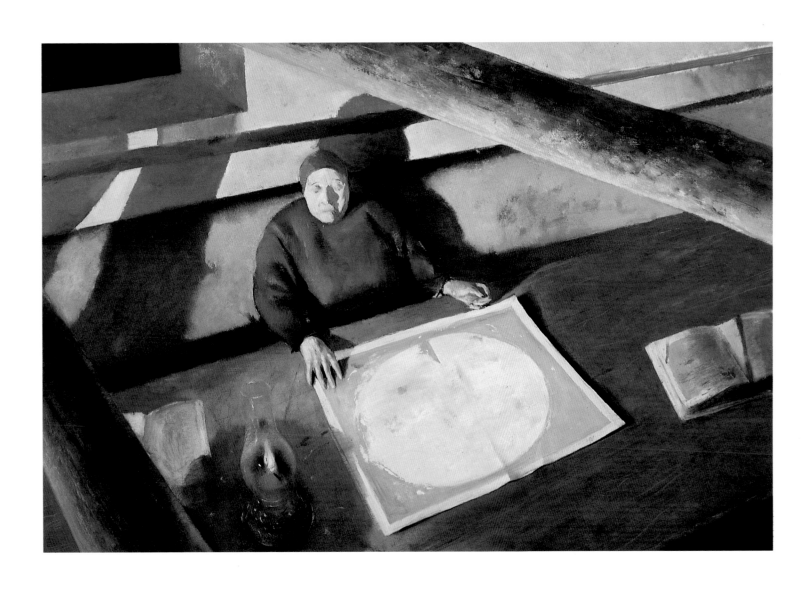

not important for us to know who they are or to be given any clues to their personalities in order to appreciate the paintings. Once known, however, their identities can provide at least a small key to understanding not only the pictures themselves, but the artist's creative process and imagination as well.

The figure in *The Chart* is actually the artist's aunt, his father's sister. "One day before her death I did a study for this picture," Larraz recalls. "She was an extremely important' person for me and, in fact, for many other members of my family. She supported me in everything and encouraged my career. In public life she was also an eminent person in her time, having been a well-respected figure in Cuban politics."

The effects of this painting are achieved in subtle ways. Among them is Larraz's manipulation of color. He alternates areas of deep, even brooding tones of gray, dark blue, and mustard yellow with whites and pinks to mitigate partially the pessimism of the scene. All of the light should logically come from the oil lamp, but there is such an intensity of illumination, especially on the map and on the face of the old woman, that the central area of the picture appears to be magically luminescent. Although *The Chart*, with its dramatically elegiac quality, is perhaps the height of what might be called Larraz's magic realism, there is an element of this in greater or lesser degrees throughout his oeuvre.

An analogous sense of fascination and disquietude is produced by two paintings depicting children. *Fiorentina* (1976) shows a girl (the artist's daughter, Saskia, was the model) in a room with the inevitable windows looking out onto a body of water. The windows are covered by gauzy white curtains, however, and the view outside is indistinct. The child stands behind a sofa so that we see only her torso. She stares deliberately not at us but off to the left in a way that suggests that something else has captured her attention. She appears somewhat puzzled or surprised. Her arm falls over the sofa; perhaps she has just let go of the doll whose head alone is visible to us. The largest and most imposing element in the composition is the giant clam atop a table or bureau (of the type that Larraz has painted several times in his still lifes) in the foreground. This unorthodox placement of the clam and the imprecise perspective give this picture an unsettling, skewed effect.

The psychological ambiguity of *Fiorentina* is echoed in a later work in which a young boy (the son of a neighbor in Nyack) plays a principal role. Looking at *Sea of Serenity*, the viewer immediately wonders if this title were not meant to confuse. Understanding this picture may well prove frustrating, for its meaning is elusive. Its enigmas fascinate and perplex us at the same time.

The young child is seated on a sofa. He is dressed in a white nightshirt and rests on a large white pillow. At his side is a mannequin—a dummy of the sort used in a store display. Here, though, it is soft and could easily collapse in a heap. It is made of white cloth (echoing the almost ghostly incandescence of the other white fabrics that dominate this vision) and is dressed in a black cutaway coat, a striped tie, and a top hat. Here, as in *Fiorentina*, the child faces left, a serious, perhaps bewildered, look on his face. Is this painting eerie and menacing or simply benign? There is an undeniable psychological duality here that allows us—indeed, compels us—to read this work on several levels. Fantasy and reality commingle, suggesting otherworldly planes or situations that could happen only in the mind.

Fiorentina, 1976
oil on canvas, 40 × 60 inches
Private collection

78

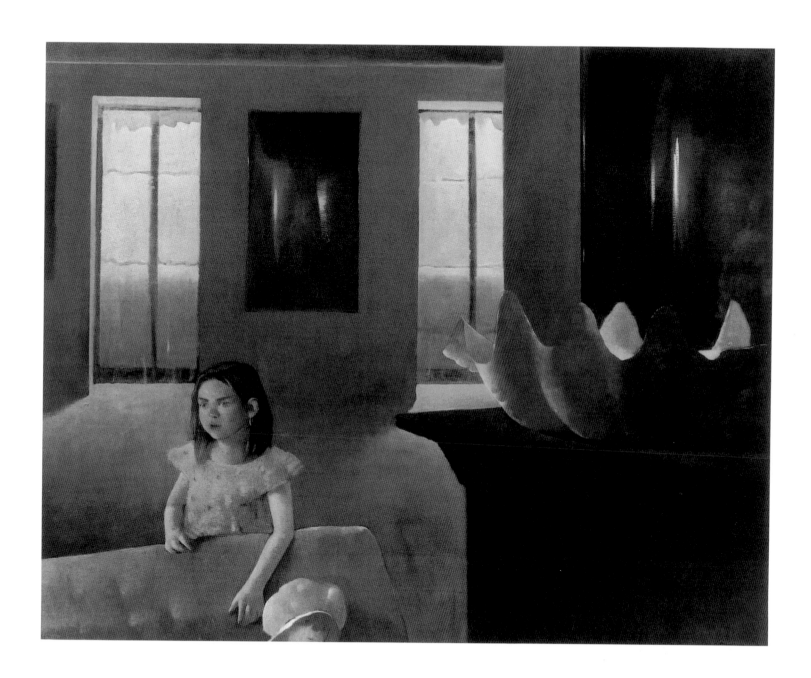

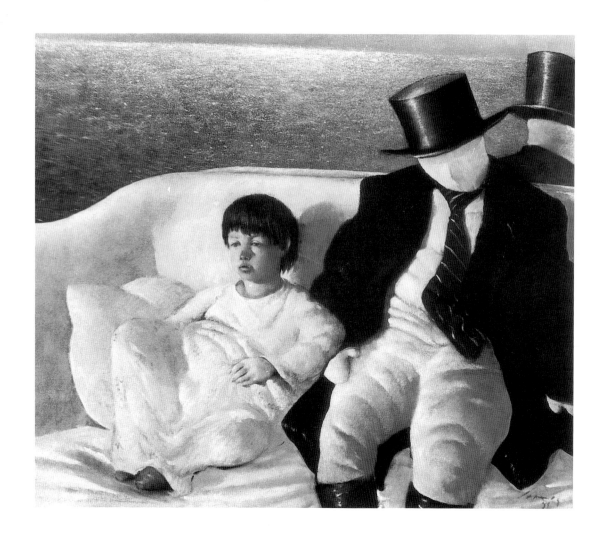

Sea of Serenity, 1981
oil on canvas, 48 × 48 inches
Private collection

These images are not unique in the long history of portrayals of children. Although many traditional depictions of them are sweet and sentimental, there are certain instances in the eighteenth and nineteenth centuries when artists endowed children with qualities seemingly alien to them. There are numerous examples in the eighteenth century, for example, in which famous men and women are represented as children. It was common during the Enlightenment to conceive of the child as already embodying the kernels of genius that would later bear fruit in that person's adult life. Even eighteenth-century portraits of children depicted simply for their own sake often suggest qualities of alertness and intelligence beyond their subjects' years. Such is the case, for example, in sculpted portraits by Antoine Houdon. Paintings of the early nineteenth century sometimes show the same curious approach to the image of the child. Certain German examples from the early Romantic period are outstanding in this respect. In 1805–6 Philipp Otto Runge painted his famous portrait of *The Hülsenbeck Children* (fig. 7). It depicts a girl and two boys who display particularly strong personalities and marked physical aggressiveness. It has been commented on several occasions that these (and other children painted by Runge) are actually metaphors for the forces of both intelligence and physical prowess that will develop as the children grow. The children in this picture are in close proximity to unnaturally large plants and flowers which are also designed to represent the powerful forces of nature in all its manifestations.

Perhaps an even closer link to the spirit of Larraz's paintings of children are several images created in the last years of the eighteenth century and the early nineteenth century by Francisco Goya. Goya (along with other Spanish and non-Spanish painters of his time) executed a number of portraits of children in which the subjects appear to be small adults. Their posture, their facial expressions, and the inclusion of symbolic accoutrements bring them out of the strict realm of childhood. The most famous of these is the portrait *Manuel Ossorio de Zúñiga* (1793; Metropolitan Museum of Art, New York), in which the boy holds a magpie on a fragile string, a temptation for several cats in the background, establishing a curious dialogue between life and death. Another such picture (also in the Metropolitan Museum of Art and obviously

well known to Larraz) depicts *Pepito Costa y Bonells* (ca. 1803), a young boy dressed in military garb and surrounded by toys such as drums and hobbyhorses that refer to the Peninsular Wars that were raging in Spain when this portrait was done. Larraz has opted not to portray the stereotypical contented child. As with Goya's depictions of children, we feel ourselves obliged to question further the sitter's identity and the circumstances under which the child was painted.

Figure 7. Philipp Otto Runge (German, 1777–1810), *The Hülsenbeck Children*, 1805–6, oil on canvas. Kunsthalle, Hamburg.

While strong color characterizes much of Larraz's work, there are certain examples where equal impact is achieved with a virtually monochromatic palette. Such is the case in *China White* of 1981, which depicts a young woman seated at a table, a cup in her hand and a nineteenth-century horse silhouette weathervane to her side. The predominant tone is white, with brown and shades of tan and cream used only for the back of the bench, the table, the horse figure, and the model's hair. The solemnity and stillness of the scene are enhanced by the vastness of the wall behind the woman and by the veiled, uncertain expression on her face. This painting represents one of the many instances in which Larraz pays homage to some of the American masters of the later nineteenth century for whom he has great admiration. In this case, John Singer Sargent is most strikingly recalled in the lush use of a single tone of paint and the large background spaces that tend to enframe the subject. Portraits such as those of *Lady Agnew* (ca. 1892–93; National Gallery of Scotland, Edinburgh) or *Mrs. George Swinton* (1897; Art Institute of Chicago) are brought to mind.

China White, 1981
oil on canvas, 40 × 60 inches
Private collection

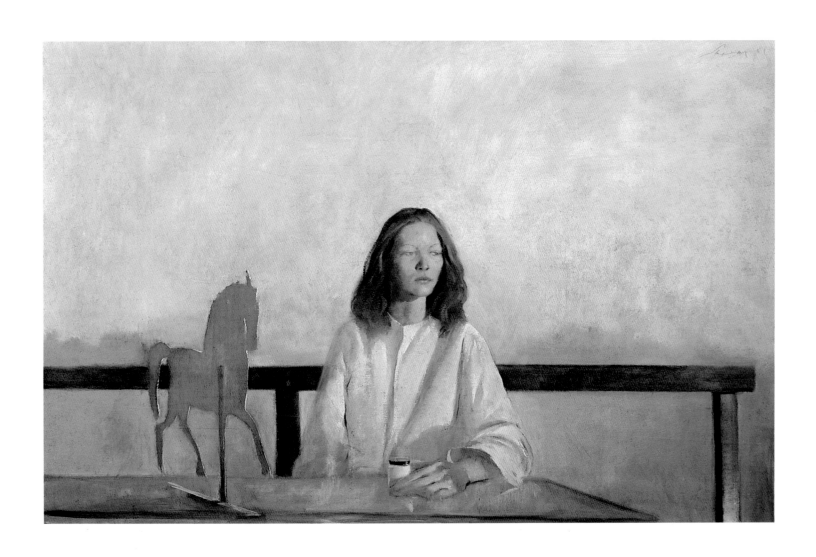

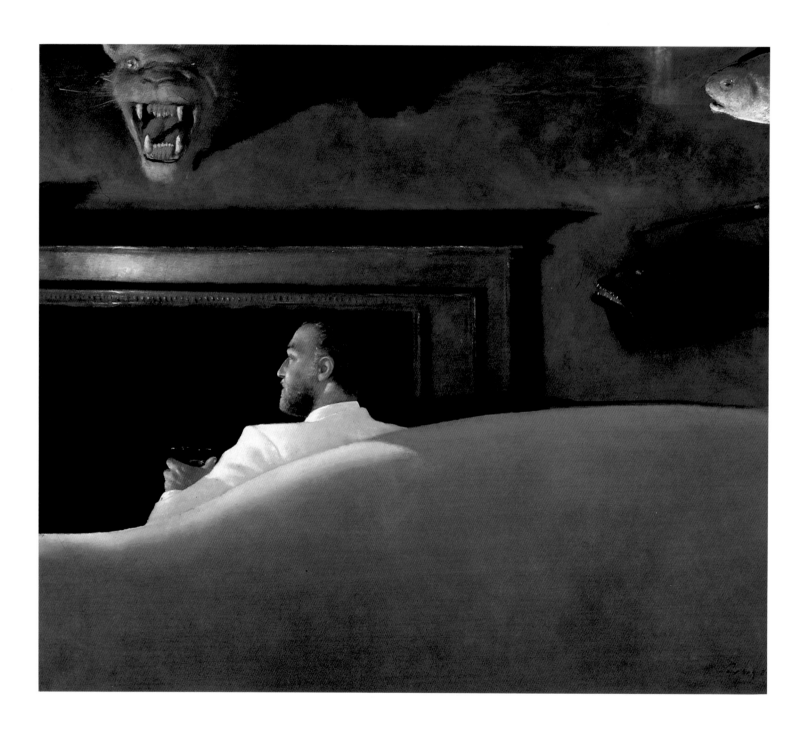

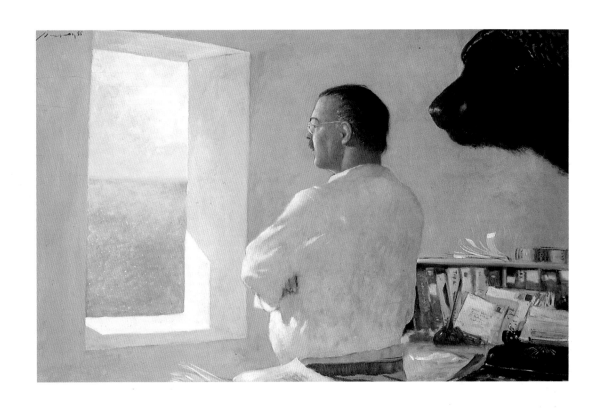

(Left) *Casanova*, 1987
 oil on canvas, 60 × 69½ inches
 Private collection

The Hunter, 1985
 oil on canvas, 40 × 60 inches
 Private collection

With the exception of several works dating from the 1970s, Larraz has rarely done studies of the nude. The 1973 *Figure in a Room*, in which we see only the back of a male figure immersed in a tub or pool, has a strange, hallucinatory quality. The illumination comes from the upper left and casts an eerie sliver of light across the top of the painting. Most of the background is made up of a massive, dark brown shadow that creates an abstract pattern against the wall. There is a weird isolation-chamber feeling here, as if the figure were being punished or were punishing himself. Some of the aura of angst can be clearly related to Larraz's inspiration for this painting in the works of Francis Bacon. Larraz has often spoken of his admiration for Bacon's extraordinary ability to combine a wide variety of emotions in his canvases portraying figures who virtually never show their faces—or whose faces are so distorted as to obscure any personality. Larraz has, of course, greatly transformed what he admires in Bacon. He does not take any specific work by Bacon as a point of departure, for he identifies with the Irish painter's ethos rather than his particular compositions.

The *Reclining Male Nude* of 1976 is a study in pastel for an oil that was never executed. All of Larraz's paintings display a careful attention to textures, but in the pastels the artist seems to revel even more in the possibility of producing a variety of tactile values. Here the nude figure reclines on a white sheet below an area of deep brown. The references to the history of art are more overt here than in other works. This figure immediately recalls several images of the recumbent Christ, the most outstanding being the *Dead Christ*, ca. 1465, by Andrea Mantegna (Brera, Milan), in which Christ is seen in dramatic foreshortening from a vantage point below his feet. Another painting of this subject by Hans Holbein the Younger (*The Body of Christ in the Tomb*, ca. 1521–22; Öffentliche Kunstsammlung, Kunstmuseum, Basel) offers an even closer parallel to the figure portrayed in Larraz's work. There is a solemn, sacramental air to Larraz's pastel as well as a suppression of all extraneous elements that is somewhat unusual in his art.

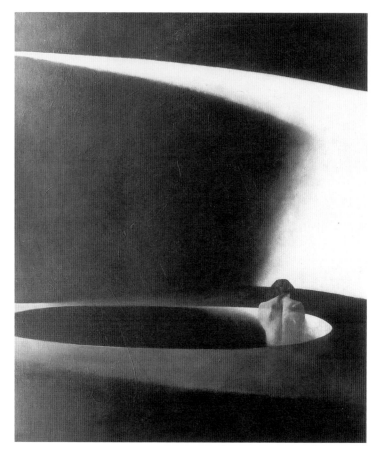

Figure in a Room, 1973
oil on canvas, 66 × 54 inches
Private collection

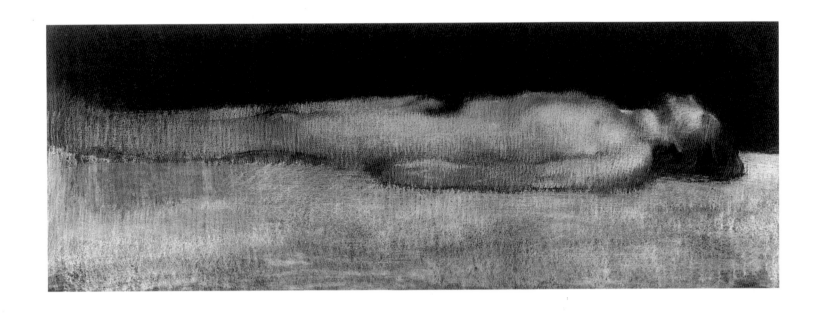

Reclining Male Nude, 1976
pastel on canvas, 15½ × 40 inches
Private collection

Many of Larraz's most outstanding figure compositions are drenched in the sun of the tropics. In looking at them, one can almost breathe the air of these southern climes. There is a strong and palpable sense of place in many of these pictures from the mid-1980s. This is not to say, however, that Larraz locates his scenes on a specific island or shore, for there is always a certain ambiguity regarding location. But it seems improbable that these works could have been done by an artist whose sensibility was not formed within the confines of the Caribbean and the Gulf of Mexico. *Eligia* of 1985 and *The Blind Storyteller* of 1987 are outstanding pictures of this type. They are somewhat related in subject and in the poses of their respective figures. Each of these canvases portrays a black woman in a room that receives the strong rays of the afternoon sun. The figure of Eligia is large; she stands next to a cooking pot in which she will mix the vegetables that rest on the table. She is in the kitchen of a very old house with thick walls and tiled floors. This may indeed be a reminiscence of a room in Havana ("Such tiled floors are common in Cuban households," the artist has said), yet there is nothing in the picture that obliges us to situate the scene there. This work also represents the type of quiet reverie shown in seventeenth-century Dutch interiors by artists such as Jan Vermeer or Gerard Ter Borch, who depicted kitchen and pantry maids who had just stopped their work to rest for a moment or to contemplate the out-of-doors. There is, on one hand, a quiet and peacefulness here, but, as in all pictures in which the subjects look out of windows at unseen things, there is also a slight unease. What can she be observing? Who is coming? Will the peace of this scene soon be disturbed? The same sense of imminent human presence that exists in many of Larraz's still lifes is found in some of these figure compositions, where we sense that there will soon be yet another person on the scene—and we cannot help but wonder how the intruder will change the atmosphere of what we see.

The figure of Eligia has a special meaning for Larraz. He based her on the nursemaid whom his family hired to care for him when he was an infant and who has stayed with the family ever since. "She is a wonderful person and meant so much to me when I was a child—and she still does. The woman in this painting is not, of course, Eligia herself," Larraz has stated, "but the figure is somewhat loosely based on the way she looked when she was young."

Eligia, 1985
oil on canvas, 61 × 82½ inches
Private collection

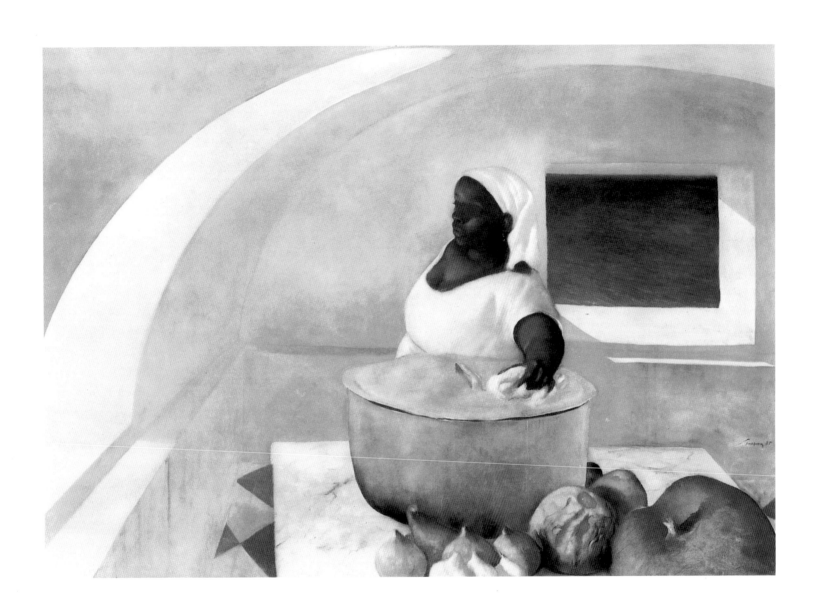

The figure in *The Blind Storyteller* is also vaguely related to that of Eligia, "but the relationship here is even less direct than in the previous picture," Larraz says. An old woman sits inside a room with a green wooden door. Sunlight enters through the slats of the window and is reflected on the wall to the left of the figure. She fans herself as she rocks back and forth, thinking, it seems, of people, places, and things she knew perhaps fifty or sixty years ago. Or maybe she is thinking of all of the tales that have been passed down for generations in her family, even from those who came such a long time ago from Africa to the Caribbean. Before her on a table are shells. Four of them are placed in a quadrangular configuration, suggesting a chart or a map. Although Larraz gives, as usual, no definite indications as to what this old woman may tell us, we intuit her powers of evocation to be great. A tension is set up between the implied subject or action of the scene and the color. A restful green serves as a foil for a slightly mysterious, slightly unsettling atmosphere here.

A large oil of 1987 entitled *Papiamento* is related to *Eligia* and *The Blind Storyteller* in both subject and mood. A young woman in a white dress with a turban on her head looks out to sea. She is shaded by the fronds of a large and lushly painted palm tree. A mood of reverie similar to that in the other two paintings is established here by the woman's longing gaze. In *Papiamento*, however, the woman shares the importance of the scene with the natural elements of the plants and the tree. She is almost encased within them and, essentially, forms an integral part of their enveloping arms—telling us that she is as much a part of the landscape and as much a symbol of the essence of this tropical island as the vegetation. One of the most remarkable aspects of this painting is the subtle manipulation of sunlight, which falls between the fingerlike fronds of the palm tree, splashing the trunk, the cactus plants, and the woman's dress and turban with dots and dashes of illumination. This contrasts with the clear and bright evocation of the unshaded beach and sea. The suggestion of varying temperatures is masterfully controlled, from the cool, breezy shadows to the more intense heat in the distance. *Papiamento* (its title derived from the creolized language based on Spanish and spoken on the island of Curaçao) is one of Larraz's most strikingly successful compositions for its expert interweaving of the landscape and the human figure.

The Blind Storyteller, 1987
oil on canvas, 53 × 79¾ inches
Private collection

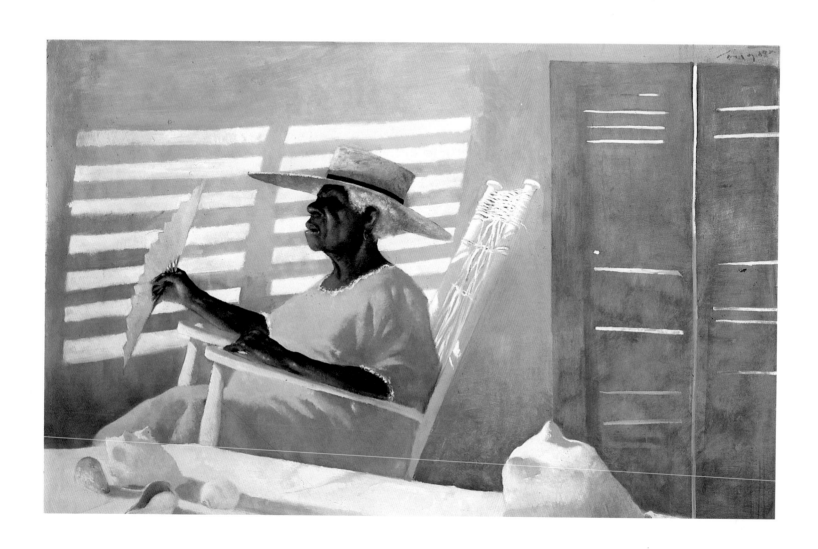

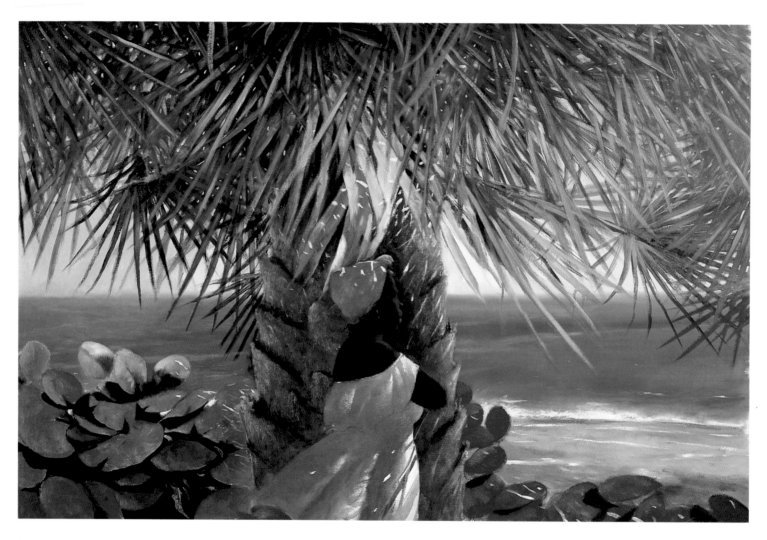

Papiamento, 1987
oil on canvas, 56½ × 82½ inches
Private collection

If in the paintings discussed here there is an indefinable, dreamlike quality, there is a more pronounced disquietude in a number of other figure compositions by Larraz. One such example is *The Trial* of 1986. At first glance this canvas (for which the artist executed a number of particularly interesting watercolors) would seem to represent a simple, harmless scene. A somewhat elderly gentleman, neatly dressed in white trousers and shirt and a red bow tie, wearing a straw hat and carrying a cane, has come to a halt during a walk on the beach. A vast expanse of sky and sea is visible behind him, as are several rows of white benches of the type found at seaside resorts around the world. Only when one looks more closely do the more ominous elements of the composition appear. At the lower left are shadows of several men. Although the shadows reveal only partial silhouettes, they are undoubtedly military figures or some unidentified police force, judging by the shape of their caps and the fact that two of them hold bayonets or rifles. Finally it becomes obvious that the confrontation with this elderly man is not merely a casual encounter. There is an implied malevolence here, a lurking sense of danger and violence made even more acute by the contrast with the calm sea and brightly illuminated beach. The artist has commented on this picture and its genesis:

This painting is not based on any specific event. This is true of virtually all of my figure compositions. However, there are reminiscences in it of events I heard about during my last several years in Cuba. At the time there were kangaroo courts set up to judge people accused of a wide variety of offenses. People would disappear and never be heard from. This happened to several people known to my family. The situation was very frightening. The apprehensiveness and the possibility of danger are what I tried to present in this work.

An uneasy sense of recognition is present also in *President for Life* of 1985. A stout, bearded man in a white suit looks out over the sea from a balcony. The vast blue expanse is relieved only in the right-hand corner of the picture by hints of several pink rooftops. Power and certainty of position are the overwhelming sensations portrayed by this figure, who contemplates what is undoubtedly his domain. Yet there is also a certain amount of vulnerability suggested here as well. This patriarchal type (in whom we may read hints of the figure of Fidel Castro as an old man) stands unprotected and possibly open to attack. His security seems as fragile as the grip of any dictator on the people he leads. In a related image, *Mayday* (1987), a woman stands behind a red barrier (a wall? a curtain?) surrounded by military officers who are represented mostly by their caps alone. Here again, there is a curious sense of isolation to this figure silhouetted against the sky. She is possibly watching a military parade or other such ceremony, but she seems set apart, as a likely victim for a sniper's bullet.

The model used in *Mayday* has appeared before in Larraz's work. A 1978 portrait entitled *Tania* presented her for the first time. "Tania," the artist has stated," is a Russian woman I knew in Nyack, New York. When I first met her, she wanted me to do her portrait. I didn't want to do it at the time, but later I realized what an extraordinary face she had and decided to paint her, as I have done several times."

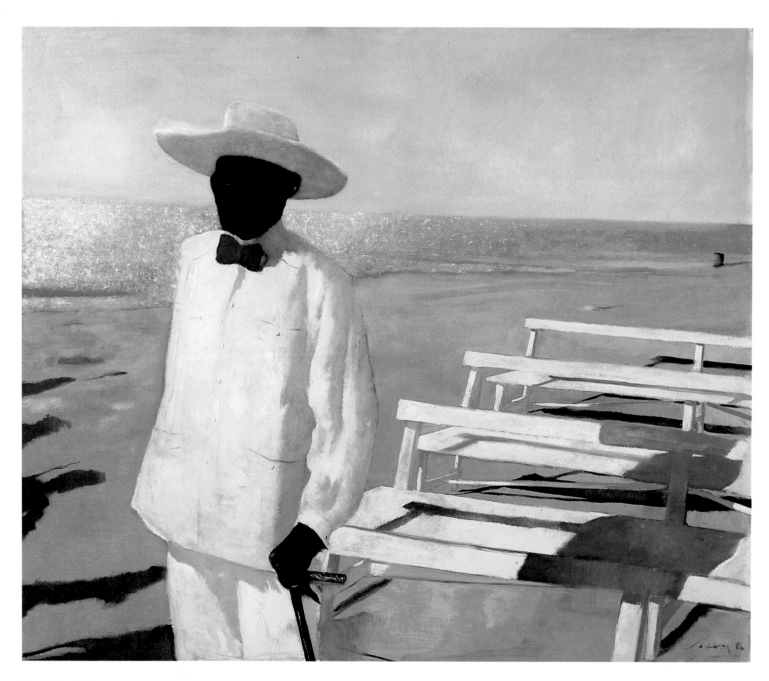

The Trial, 1986
oil on canvas, 61½ × 71 inches
Private collection

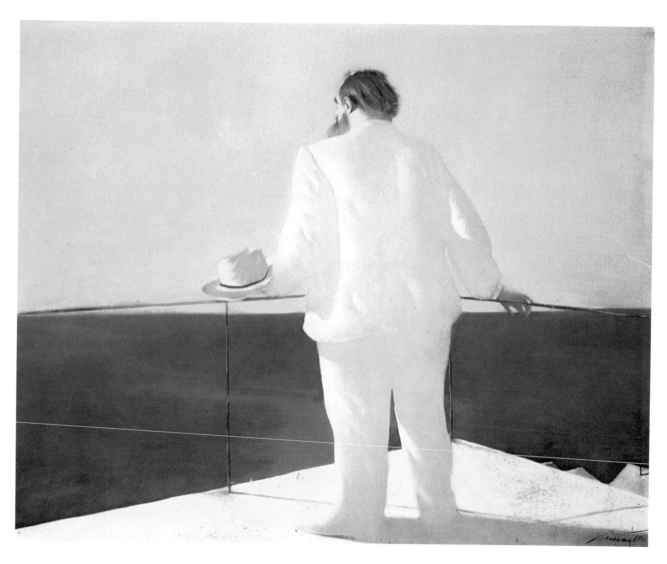

President for Life, 1985
oil on canvas, 50 × 59½ inches
James H. Friend

Tania, 1978
oil on masonite, 24 × 36 inches
Private collection

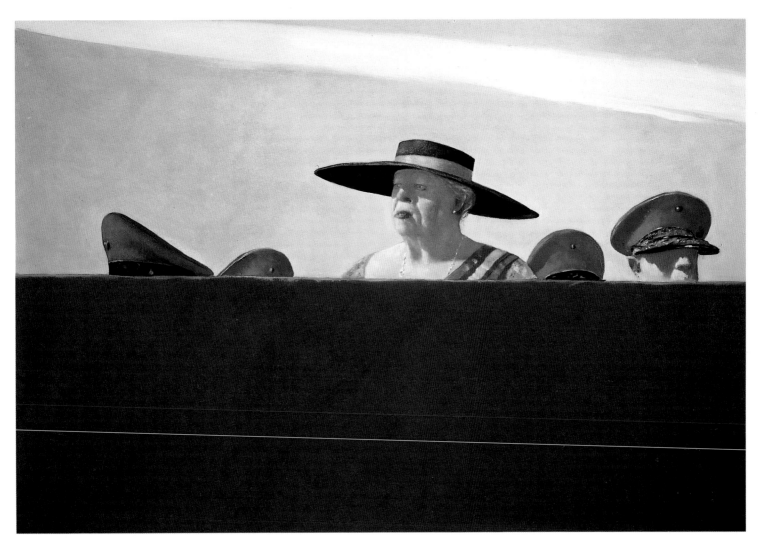

Mayday, 1987
oil on canvas, 49 × 69½ inches
Courtesy Thommas Ammann, Zurich

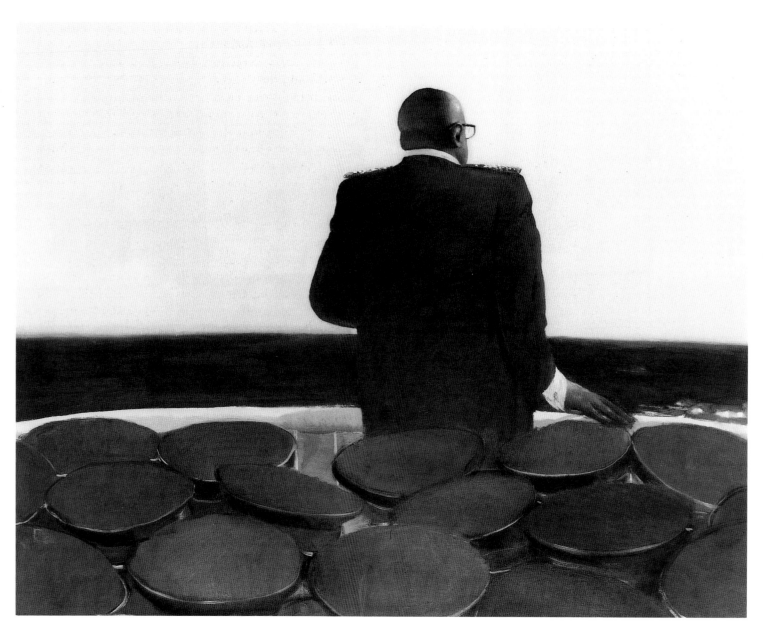

Le Président à vie, 1985
oil on canvas, 49½ × 58½ inches
Collection of the artist

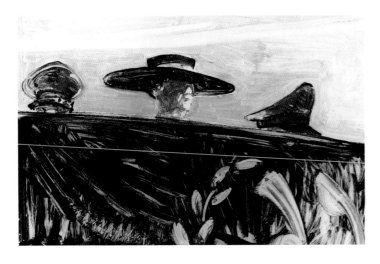

A work related to the series represented by *President for Life* and *Mayday* is *Le Président à vie* of 1985, which, as its title suggests, deals with the same theme as *President for Life*. Here, though, the references are more specifically military as a stout, bald, black man in army uniform stands above a large group of officers. He turns his back on both the officers and the viewer. He seems not to be addressing anyone because there are only the beach and a few rooftops beyond. We are made uneasy nonetheless by the strong concentration on his back. Everything appears calm and ordered, but as history has proven countless times, chaos usually follows the tranquility of a dictatorial society.

Both *Mayday* and *Le Président à vie* are paintings for which Larraz executed studies in monotype. As in many of his preparatory works or his variations after an already-finished canvas, there are interesting changes and manipulations in the compositions of the monotypes. In the *Mayday* monotype, the position of the woman is reversed (due to the print process), and the cloth below her is made more festive by the inclusion of leaf motifs. In the monotype entitled *Président à vie*, however, the essential meaning of the image is somewhat altered by showing the subject as actually delivering a speech before a group of microphones, making it a less ambiguous scene.

Président à vie, 1987
monotype, 30⅝ × 47¾ inches
Courtesy Nohra Haime Gallery, New York

Mayday, 1987
monotype, 30⅝ × 47¾ inches
Private collection

In *Mayday* we are given a glimpse of a woman who is a person of power and importance. Is she a dictator or, perhaps, the wife of a political figure? We do not know. Certain essential keys are missing. This is, of course, a calculated strategy on the part of Larraz, who will never reveal every clue of his pictures to the viewer. The same is true of *The Reception*, a pastel of 1986. Here a woman, again with her back to the viewer, stands in a room with her right arm extended in greeting to someone outside the space of the scene. She is thrust to one side so as to make her appear as an ancillary figure, of lesser importance than other elements of the picture, namely the window with its inevitable ocean view and, especially, the enormous shell resting on a table in the foreground. The shell is so imposing that it takes on a quasi-human presence. There is another aspect of this work that removes this scene even further from the realm of the ordinary. Larraz has used maps here as in other works. In *The Chart*, for example, the map employed was that of no earthly place. In *The Reception* the map appears more specific, yet we still cannot perceive it as a true cartographic record of any particular location. Larraz has said, "I have sometimes used maps in the way that Vermeer used them—to signify places far out of reach of the reality of the characters in the scene."

The Reception, 1986
pastel on paper, 45¼ × 66½ inches
Tambrands Corporation, Lake Success, New York

Olive Green, 1986
oil on canvas, 70¾ × 69 inches
Private collection

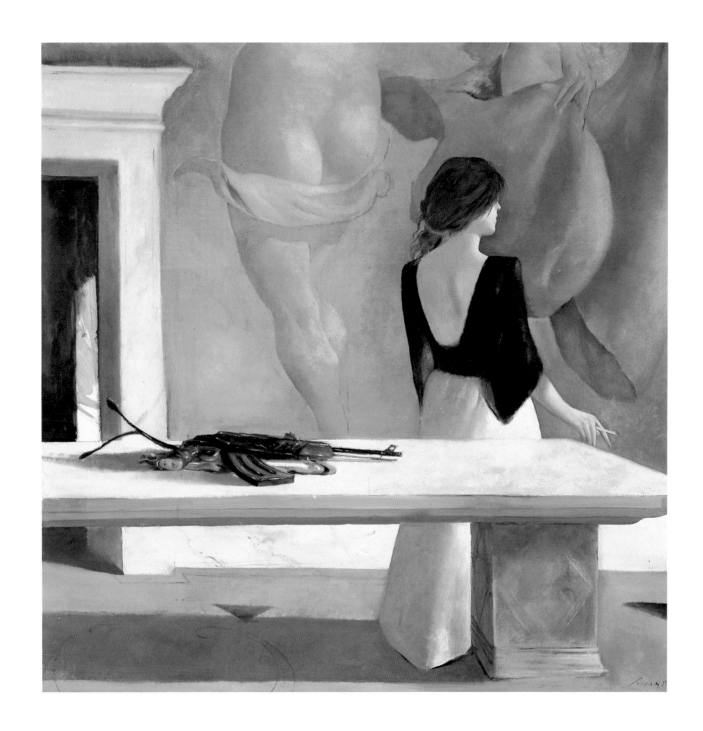

Maps also play a key role in *The Thief*, an oil of 1985. The scene itself is incongruous. A rather elderly man (based on the figure of a friend of the artist) dressed in evening clothes enters a room through a window. It appears to be an elegant chamber with its marble-top table, crystal vase of flowers, and bronze sculpture. On the walls are very large maps, also of unlocatable places. This improbable situation might be more explicable as part of a surreal fantasy by Magritte, for example. Why should such a prosperous-looking man enter this room through a window? He looks too fragile for this kind of activity. Perhaps the maps might serve as clues. Are they maps of war zones (as the inscription at the lower part of the right-hand map might indicate)? Is this man here to steal state secrets? We have no answers but our own imaginations.

Larraz has demonstrated a fascination with the figures of elderly men. Among them is the model for *The Giant* of 1975. "I used to go swimming," Larraz has explained, "at a pool where a truly mammoth man would go. He was large in every way. His shoulders would reach from one side of the doorway to the other and he was extremely tall. Everyone was amazed at his size." Here he is seen sitting in a pool where the water covers his body up to his waist. He turns his head to the right and his face is lost in shadow. His bald head and massive form create of him an abstract shape. He is painted not in the atmosphere of a modern pool, but in what would appear to be a huge chamber, reminiscent of the baths of ancient Rome. Indeed, this figure recalls the behemoths described in some of the writings of ancient authors such as Petronius, who paints a verbal portrait of a man not dissimilar to this one in his *Satyricon*. Larraz's giant appears to be the embodiment of excess. The disquieting sense of unreal space is enhanced by the arched doorway in the background. "I was inspired to paint this space," Larraz states, "by looking at Velázquez's picture of *The Spinners* in the Prado." This is a free borrowing from the Old Master, as Velázquez's picture does not contain an arch over the door, although the sense of recession is similar in the Larraz to that in the seventeenth-century picture.

Regarding the veiled, uncertain identification of the *Giant*, the artist has said:

I am enormously attracted to things that are not actually seen, but are intuited. In my family's house in Havana, there used to be a painting—perhaps a copy of a painting, I don't know—of Franz Liszt playing the piano. At one side of the picture were the hand and sleeve of an unknown figure who was about to enter the scene. As a child I was fascinated by it and used to ask my mother what it meant. She told me that it represented death. This idea, of the possibility of something menacing entering a room or a space, has stayed with me since that time.

In the 1987 painting entitled *Audience*, we see a white-robed figure, perhaps an ecclesiastic, seated on a Renaissance chair. His shoulders and head are completely obscured by a large yellow curtain that hangs from the upper left. His personality is thus obliterated, but he holds in his hand a helmeted falcon that looks out directly at the audience. The pose of the figure is based on that of countless Renaissance and Baroque state portraits of both political and religious leaders. Larraz, however, went to a specific source for the idea of his veiled figure: Titian's portrait of *Archbishop Filippo Archinto* (fig. 8), which Larraz had seen in the Philadelphia Museum of Art. "The veiled effect of that painting was extremely interesting to me, and I wanted to incorporate something of that feeling into my work," he has said.

Figure 8. Titian (Italian, c. 1488–1576), *Archbishop Filippo Archinto*, 1558, oil on canvas. Philadelphia Museum of Art, John G. Johnson Collection, J204.

The Thief, 1985
oil on canvas, 51 × 59 inches
Westinghouse Electric Corporation, Pittsburgh

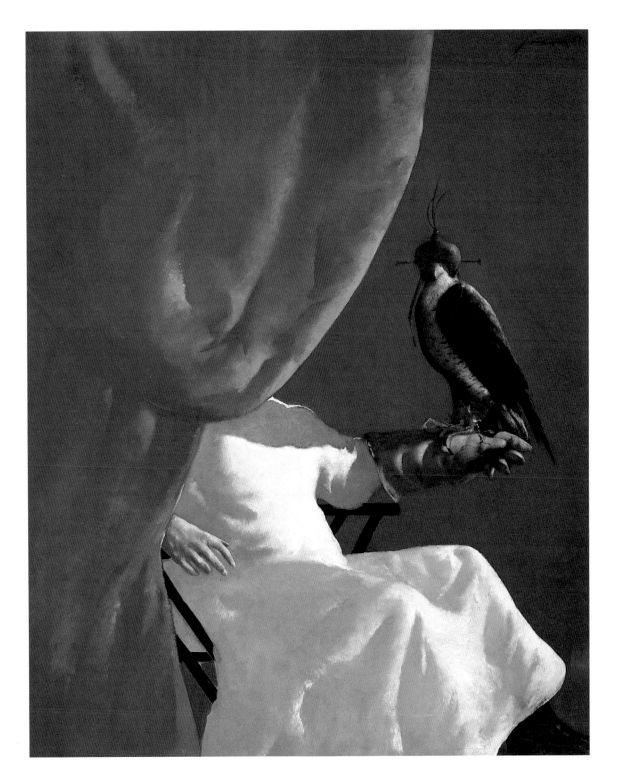

(Left) *The Giant*, 1975
 oil on canvas, 60 × 40 inches
 Collection of the artist

Audience, 1987
 oil on canvas, 69 × 53½ inches
 Private collection

Although the conceit employed in *La Favorite* (1985) is similar to that of *Audience* (both involving figures whose faces and bodies are mostly concealed by curtains), there is little of the overt sense of mystery in the former. The figure is reclining instead of sitting. Only two hands are visible; the bulk of the body is suggested beneath the bedclothes. The setting is obviously one of great luxury, as the sheets and curtains appear to be of silk and satin. As in *Audience*, an animal faces the viewer as a surrogate witness for the hidden master or mistress. Here we observe a cat as it observes us with wide open eyes and a quizzical look, immediately bringing to mind a similar cat in Edouard Manet's great bedchamber composition, *Olympia* (1863; Musée d'Orsay, Paris). It was not to Manet, however, that Larraz looked for inspiration for *La Favorite* but to a somewhat more obscure source. "I based this work loosely on a picture by the French eighteenth-century portraitist Hyacinthe Rigaud, who painted King Louis XVI in bed," the artist has said. In light of this, the fleur-de-lis pattern on the bedcover takes on a new significance —although the composition is not meant to be interpreted as a latter-day representation of the French king.

La Favorite, 1985
oil on canvas, 68½ × 72½ inches
Dolores Smithies, New York

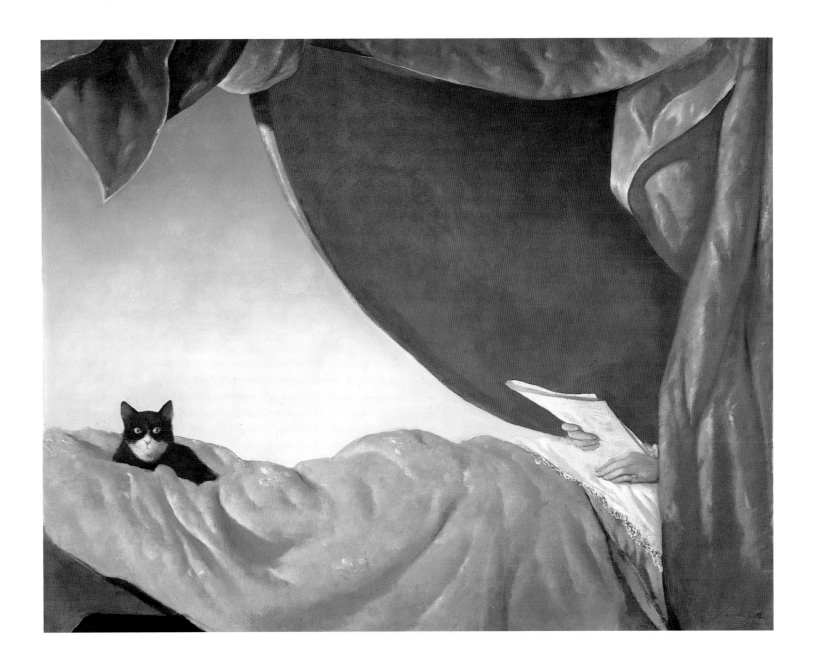

Many of Larraz's figure compositions contain an implied or oblique narrative quality, but he seldom turns to direct literary sources for his works. One exception, however, is *The Headless Horseman* of 1984, a large painting in which the figure of a colonial soldier, eerily holding his head in one hand, sits astride a large black horse. The horse's head is virtually flush with the picture plane, and one eye stares at the viewer. A night sky is illuminated with hundreds of tiny stars. The scene is, of course, based on the famous tale by Washington Irving, "The Legend of Sleepy Hollow." The story was written at Irving's home called Sunnyside, located only a few miles from Larraz's house in Grandview, New York. The artist painted this picture not in Grandview, but in Paris. "I guess I was thinking very much about home and the United States and wanted to do a very American picture, being far away from the country that I'd adopted," Larraz has stated. Although this painting has a recognizably literary theme, it should not be read as an illustration. It is significant that Larraz has chosen one of the most bizarre of American short stories from which to draw his inspiration. The episode of a headless rider in pursuit of a timid and frightened man (Ichabod Crane) accords very well with the artist's quasi-Surrealist imagination and may be understood as an extension of it.

The Headless Horseman, 1984
oil on canvas, 50 × 69 inches
Private collection

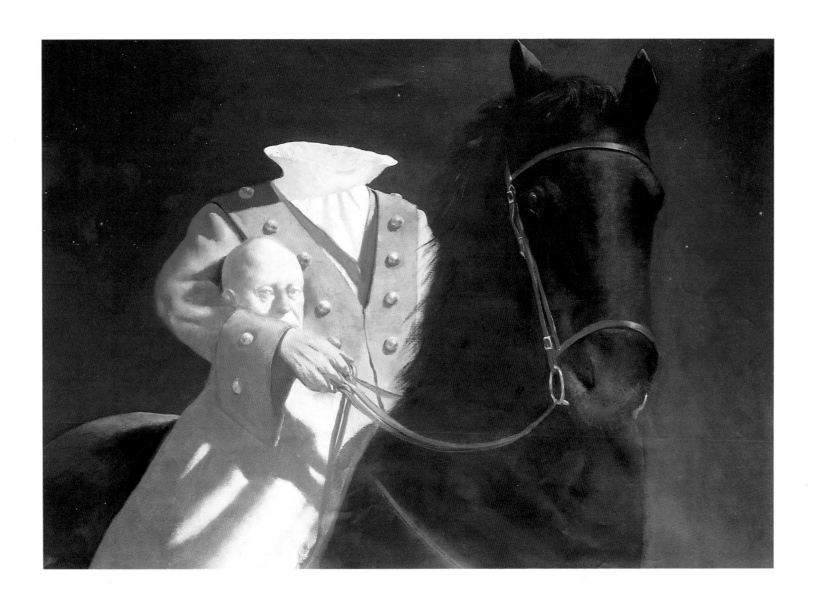

Larraz has created several pictures that include figures based
at least tangentially on famous authors. In the mid-1970s he
painted two works, *Reflections* and *Dinner at Negresco's*, in
which the principal figures represent Somerset Maugham.
Both of these paintings are affecting portraits of the nobility
of old age. The man sits alone at his dining table, but he does
not reflect loneliness or solitude. On the contrary, he seems
perfectly in charge of a vast intellect, aware of the world
around him, ready to make any incident he observes the
subject of a literary masterpiece.

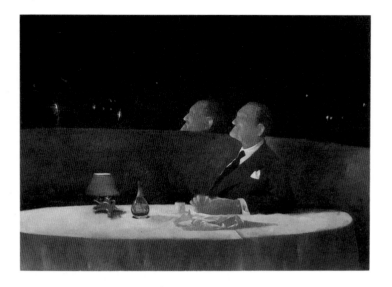

Dinner at Negresco's, 1974
oil on canvas, 48 × 66 inches
Private collection

W. S. Maugham Study, 1974
oil on masonite, 10 × 8 inches
Private collection

Reflections, 1974
oil on canvas, 60 × 72 inches
Private collection

Until now this commentary on Larraz's figure paintings has concentrated on single figures or small groups within rooms, on terraces, or on the beach. But there is another subcategory of works that take place on the sea. In 1986 Larraz executed numerous pastel studies for a planned (but as yet unexecuted) painting to be entitled *Night Fishing*. One of these is a haunting work depicting a group of men in a boat illuminated by what would seem to be the fragile light of the moon. Some are rowing while others are merely sitting in the vessel. Although some of their faces are indistinct, there is a marked look of anxiety on those of others. While this painting could be superficially related to other scenes of night fishing in the history of art (the most obvious comparison being the lyrical *Night Fishing at Antibes* of 1939 by Pablo Picasso [Museum of Modern Art, New York]), it is more fully understood in light of the personal meaning that it carries. *Night Fishing* is related to an earlier painting, dated 1973. *The Refugees*, one of the few paintings Larraz has done in acrylics, depicts a much more turbulent scene of men and women in a boat passing through rough seas below a troubled sky. Although Larraz is not making an overt political statement, given the recent history of immigration from Cuba, the message here is clear. This painting shows the terror of those who crossed the ninety miles that separate the northern coast of Cuba from Florida in small, flimsy boats. Years later he took up the same subject, as if it were a ghost that pursues him and must be exorcised. "Although the title of the work is benign," says the artist, "it's a painting that obviously deals with the same theme, that of refugees fleeing from the terror of their lives in their own country." One may expect that in the future years of the painter's career this theme will recur in different guises, revealing more and more about both his visual conception of figures afloat on a body of water and, more importantly, his emotional approach to an issue of great personal meaning.

Study for "Night Fishing," 1986
pastel on paper, 45¼ × 66½ inches
Collection of the artist

Study for "Night Fishing," 1986
pastel on paper, 19¾ × 25⅝ inches
Private collection

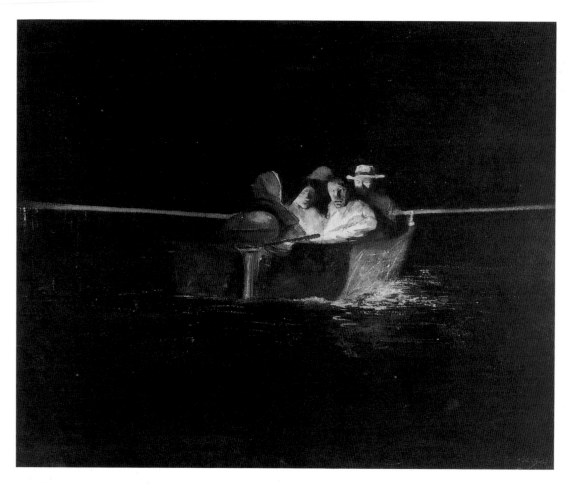

Study for "The Refugees," 1972
watercolor, 13 × 15 inches
Collection of the artist

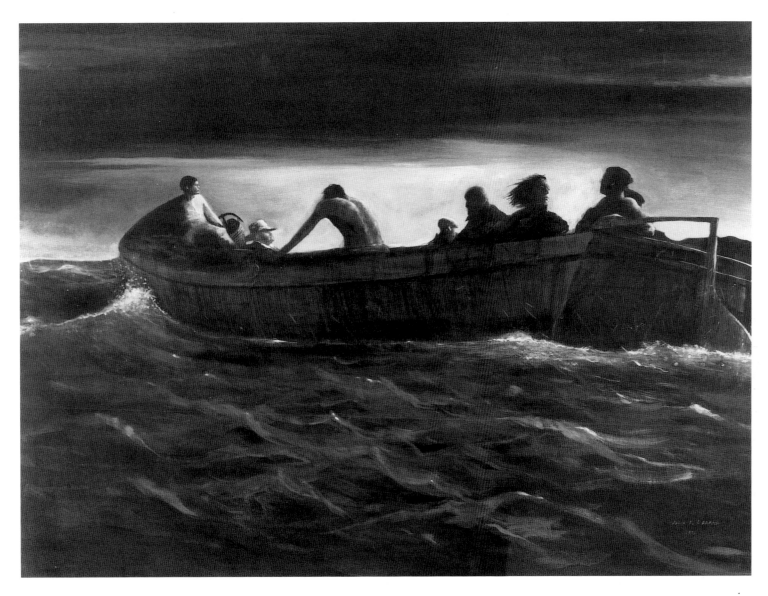

The Refugees, 1971
oil on masonite, 30 × 39 inches
Mr. and Mrs. Julio César Fernandez, Miami

Larraz is not the only Cuban-American artist to treat the theme of exile with images of boats on the sea. Luis Cruz Azaceta has done so, although with a very different technique. His highly expressive canvases, including the 1986 *Journey* (Allan Frumkin Gallery, New York), portray an emaciated lone figure adrift in a tiny boat. The boat represents, of course, the mode of transport of thousands of persons over the dangerous waters, but it is also a metaphor for the mental and physical suffering caused by displacement.

Another work by Larraz dealing with sea imagery (although on a much less ideologically charged level) is a painting of 1986, with many pastel studies, entitled *Lost at Sea*. This is one of the artist's most compelling pictures with regard to perspective and the placement of elements. In it we see a room with two large windows and views of the sky and sea. In the upper part of the composition there is a vast blue space in which a large sailing vessel seems to float, surrounded by mythological figures of Neptune in his chariot accompanied by Nereids. What we observe is completely explicable when we understand the painting's genesis. "Several summers ago," Larraz has said, "I spent some time in the south of France, in Saint-Jean-de-Luz. One day I went into a church and saw a very beautiful painted ceiling. A boat, which represented a votive object donated by fishermen who had been protected on their journeys, hung from the ceiling. I did many sketches and pastels of them and ultimately did this picture, adding the mythological figures to what I'd seen in the church."

The pastels for *Lost at Sea* express even more poetic sensibility than the painting. They also show a baroque exuberance that sets them apart from some of his other works in this medium. In these works Larraz revels in a mode of fantasy that plays as a leitmotif throughout his work.

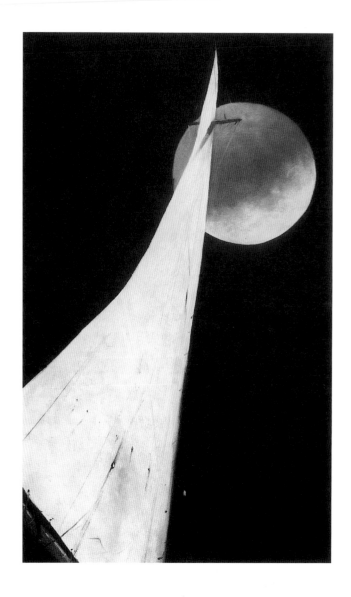

Southern Cross, 1986
oil on canvas, 51½ × 30½ inches
Private collection

Lost at Sea, 1986
oil on canvas, 77 × 78 inches
Private collection

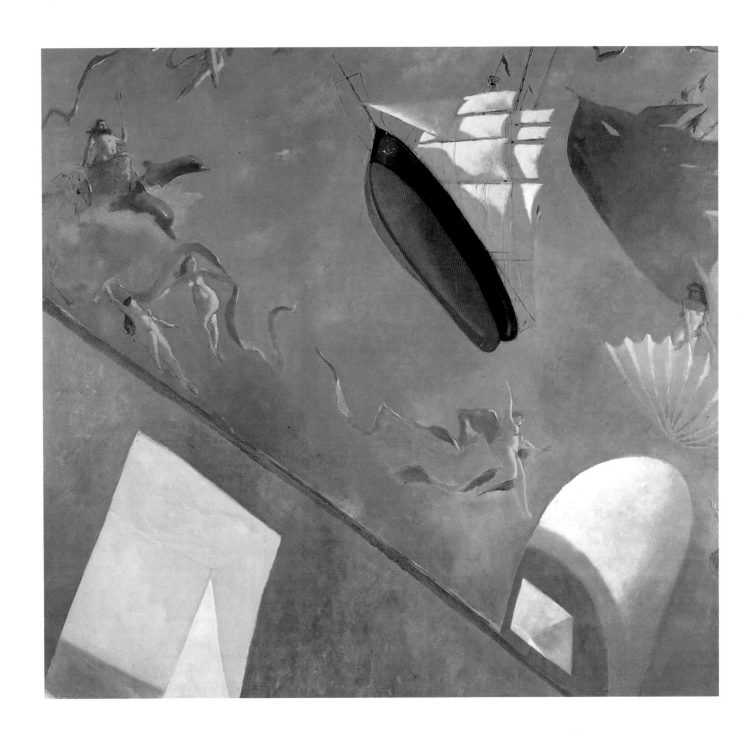

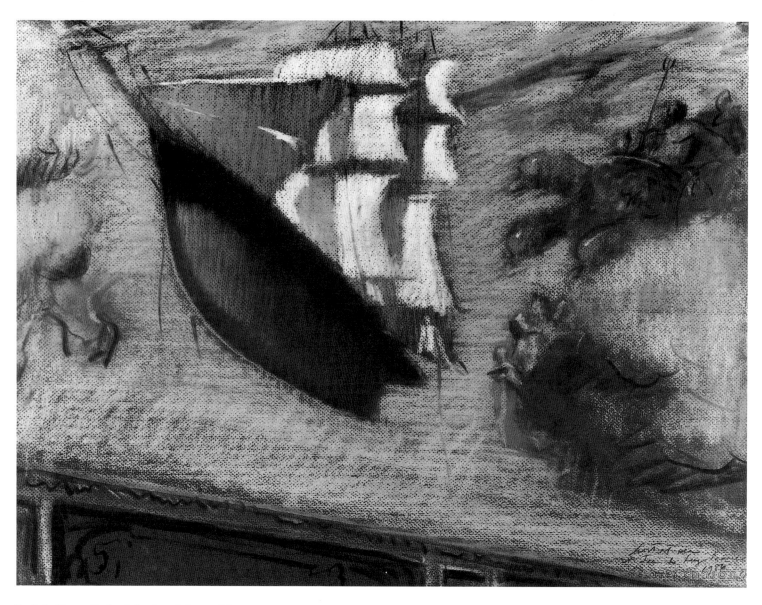

Study for "Lost at Sea"—Saint-Jean-de-Luz, 1986
pastel on paper, 19¾ × 25⅝ inches
Private collection

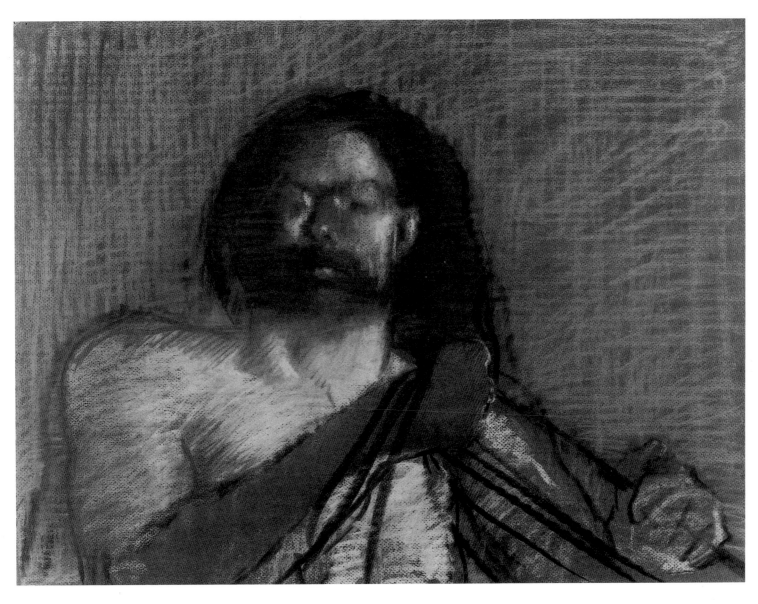

Study for "Lost at Sea"—Neptune, 1986
pastel on paper, 19¾ × 25⅝ inches
Private collection

Larraz has expressed his interest in painting large-sized pictures. "Expansiveness," he has said, "goes with the aesthetics of our time." He has also said, however, that the largest size with which he feels comfortable is roughly sixty by seventy inches. There is one work, however, in which he has surpassed these barriers. The triptych entitled *Crossfire* of 1974 is indeed composed of individual canvases that are within Larraz's self-imposed size limits, yet it must be considered as a whole, with the three panels inextricably linked both visually and psychologically. One ideally begins to read this work at the extreme right, where two men, one in a suit, the other in a white laboratory coat, are standing within a round glass enclosure. Everything is dark; deep shadows are cast across their faces, and only a few distant lights illuminate the scene. There is a brooding and uneasy feeling here, as if a drama were about to begin, but we do not know the protagonists and we cannot comprehend what is going on. A science-fictional sense of insecurity characterizes this image. As we move on to the middle panel, we see an even more bizarre occurrence—a man of late middle age stands with his arms raised to the level of his chest. His shirt is open and his mouth forms a silent scream as his body is pierced by the rays of a red laser beam. This same man lies, apparently dead or mortally wounded, in the left-hand panel. What are we to make of this scene of inexplicable torture? The most interesting parallels to this unusual work by Larraz are to be found in paintings by the American artist Vincent Desiderio and the Norwegian artist Odd Nerdrum. Both of them paint in a tactilely sensitive realist style reminiscent of Old Master techniques and often include moralizing messages in their large, ambitious works. Desiderio's pictures are particularly close in spirit to Larraz's *Crossfire*. Larraz has stated, "I wanted to express a universal message of human suffering in this triptych." Here Larraz succeeds in departicularizing torture and pain. The stout victim becomes an everyman figure, a metaphor for a worldwide condition of suffering.

Crossfire, 1974
oil on canvas (triptych), 60 × 152 inches
Nohra Haime, New York

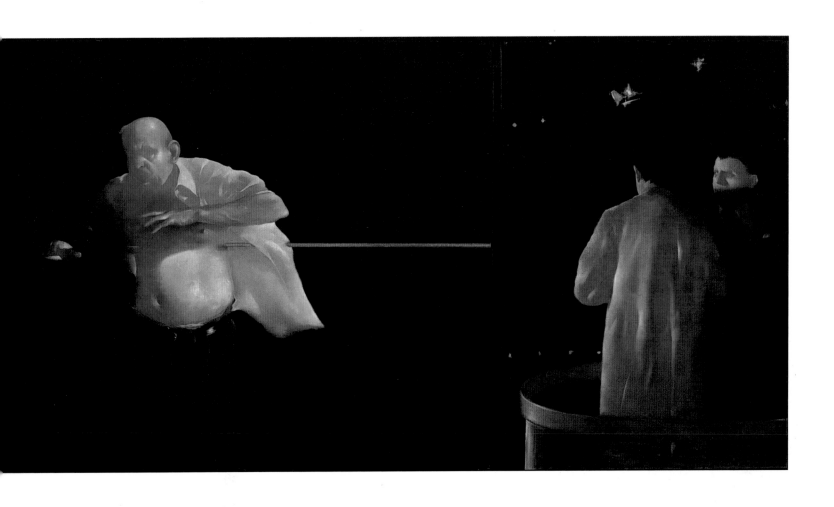

Open Windows and Empty Rooms

Of all the compositional and mood-producing elements in Julio Larraz's work, that of the open window is one of the most pervasive. In figure paintings the window sometimes serves as an implied means of escape from the mundanities of everyday life, a path to new and unknown experiences. At other times, as in *The Thief*, the window serves as the vehicle for illegal entry. Windows in Larraz's work usually assume one of two shapes, being either large and rectangular or smaller and set within dormers. They invariably indicate the thick walls of solidly built old houses. Out of these windows the sea is almost always visible, and on its surface a brilliant sun is usually reflected. These elements are more than just coincidental or casually conceived. They express the artist's longing for both a place and a state of mind.

Some of Larraz's most extraordinary pictures portray these windows and nothing more. In several instances there are corners of the rooms included in an oblique, almost offhanded fashion. At other times the empty or almost-empty rooms are the focal points of the compositions. Among the most interesting examples are three paintings from 1982, 1983, and 1984 respectively: *Amontillado, The Sea of September*, and *The Hurricane Season*. All of these are essentially simple but infinitely sophisticated depictions of their subject. Only in *The Sea of September* does another element (the shell) disrupt our contemplation of the window and the sea. In both *Amontillado* and *The Hurricane Season* the window exceeds its strictly representational role and verges on the realm of the abstract—the values of tactility and light gain dominance. The coloration of both of these works is extremely subtle. The artist uses the area of the wall and inner portion of the dormer as a pretext for studying modulations of white, pink, and yellow. Below the window are rust stains or marks, indicating that at some time in the past rain entered the window and water poured into the room. "These water marks—age marks, I call them—are signs of life that I give to old windows, pots, and other things," Larraz has said.

The Hurricane Season, 1984
oil on canvas, 50½ × 57½ inches
Collection of the artist

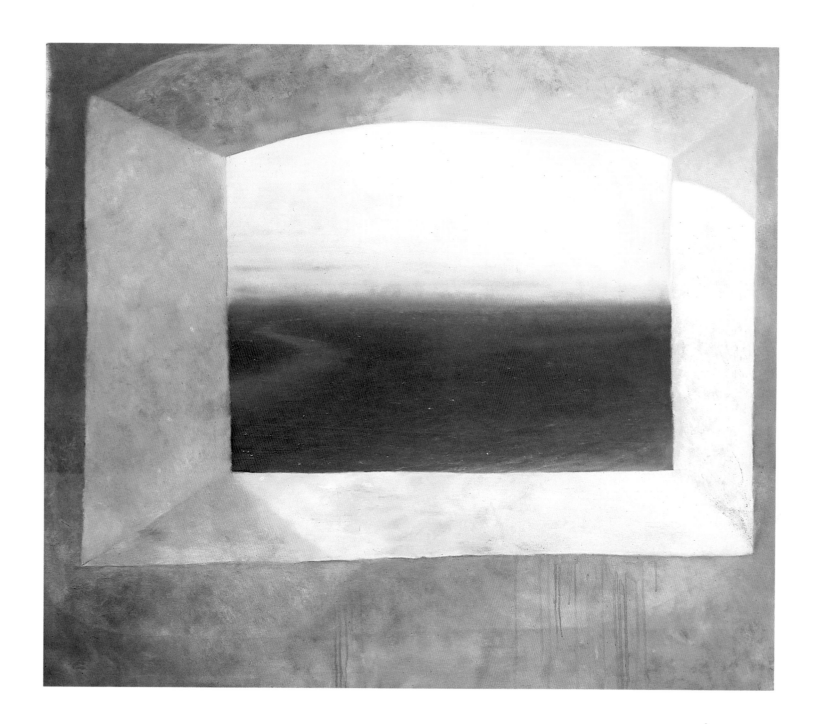

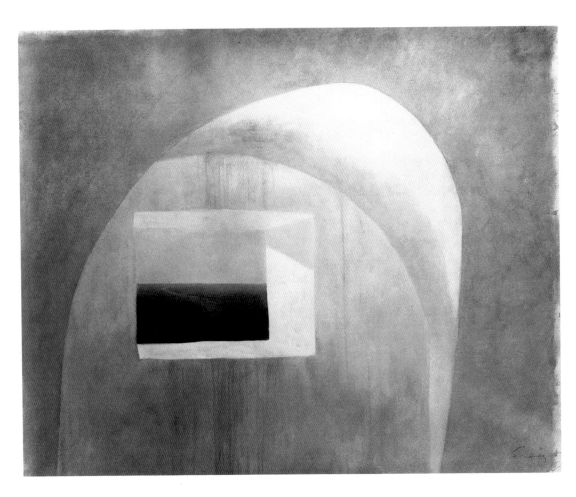

Amontillado, 1982
oil on canvas, 51 × 59½ inches
Private collection

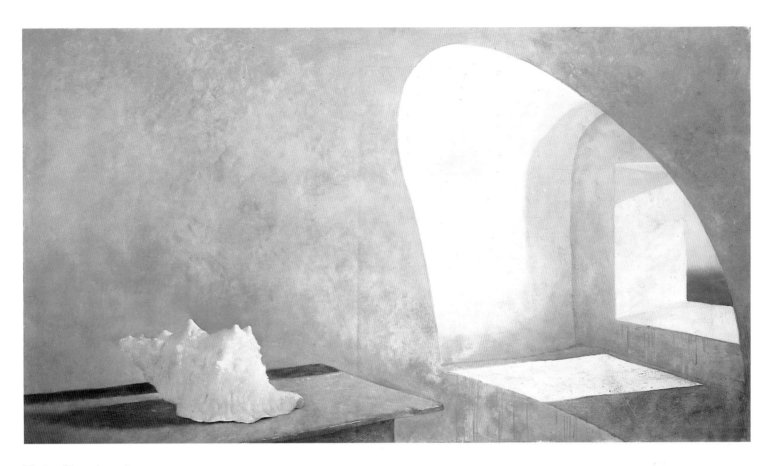

The Sea of September, 1983
oil on canvas, 47 × 83 inches
Mr. and Mrs. William Nitze, Washington, D.C.

In *South Wind* and *Study for "The Governor's House" with Murex* the same elements of window, sky, and water are present, but with something added. A starkly simple table or a geometrically pure bench enters the scene to participate in this play of forms. Many of these pictures recall the abstract harmonies created by Richard Diebenkorn from the simple elements of sand and sea, or, even more directly, the semiabstract patterns fashioned by Georgia O'Keeffe from the sides of New England barns or adobe churches in New Mexico.

Many of these pictures contain still lifes of flowers, fruits, vegetables, or other elements (in *Sea of Rain*, flowers, pears, and apples rest on a marble-top table; in *Queen's Fort*, a vase of white tulips is seen; and in *La Sorcière*, a large saucepan plays a central role). Nonetheless, even here the primary focus appears to be on the empty room. Depictions of empty rooms are relatively few in the history of art. Although many artists in the eighteenth and nineteenth centuries worked with this theme, the pieces were almost always studies for later figure compositions (for example, Eugène Delacroix's *Count de Mornay's Room* of 1831–32 [Musée du Louvre, Paris]). There are a few notable exceptions, however. Some of J.M.W. Turner's most beautiful watercolors are of empty rooms at Petworth. In 1845 the German artist Adolf Menzel painted an evocative view of his room devoid of people; *The Room with a Balcony* (Nationalgalerie, Berlin) has much the same quality of implied human presence seen in many of Larraz's paintings. Finally, in the early years of this century, the American painter Walter Gay made a specialty of painting empty rooms, both in the United States and abroad, which are intended to reveal as much about the absent inhabitants as conventional portraits would. In the case of his representations of rooms in historic buildings, they can also conjure up pictures of a specific era.

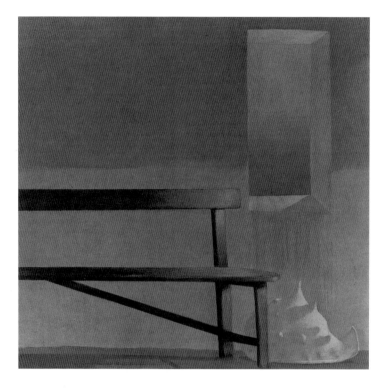

Study for "The Governor's House" with Murex, 1982
oil on canvas, 48 × 48 inches
Private collection

126

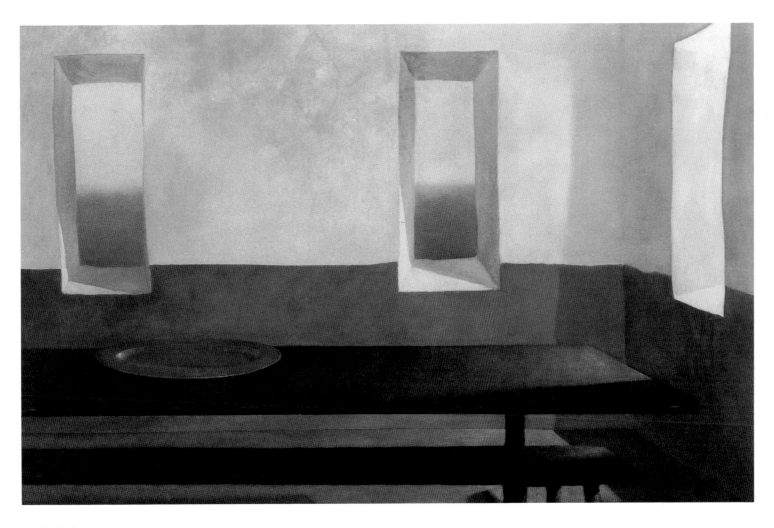

South Wind, 1983
oil on canvas, 48 × 72 inches
American Express Bank, Paris

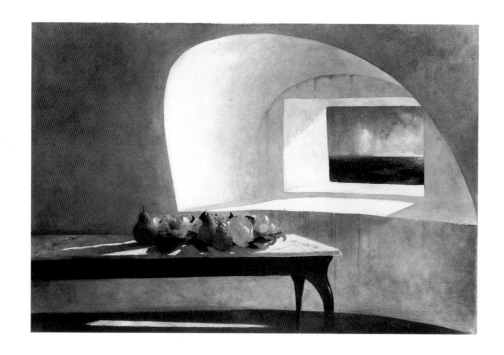

Sea of Rain, 1984
oil on canvas, 56½ × 82 inches
Private collection

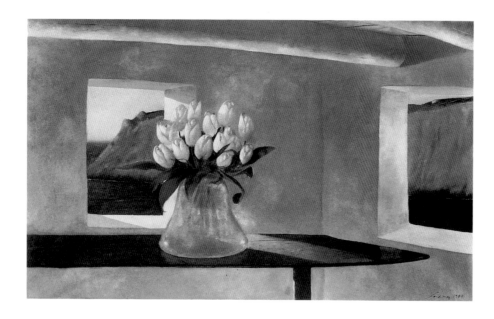

Queen's Fort, 1987
oil on canvas, 53 × 83½ inches
Mr. and Mrs. Roman Martinez IV

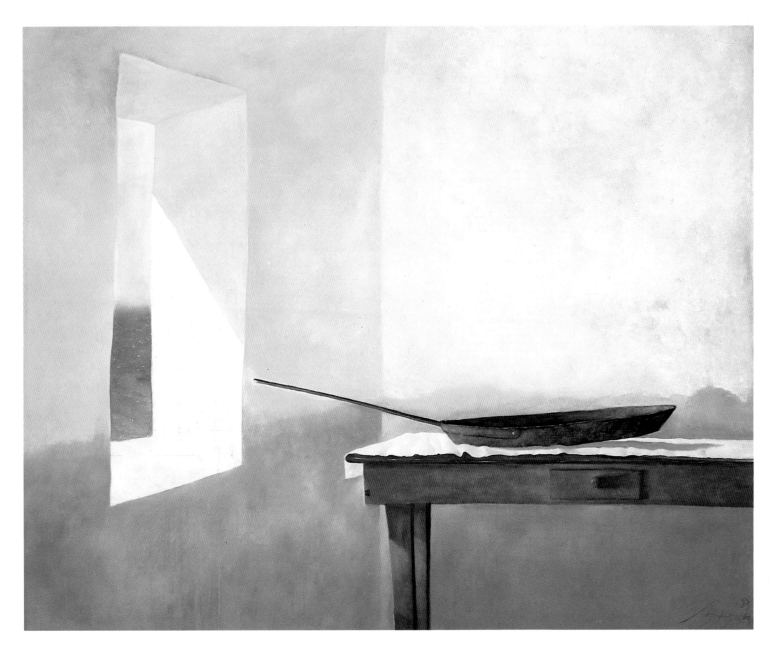

La Sorcière, 1983
oil on canvas, 70 × 81½ inches
Private collection

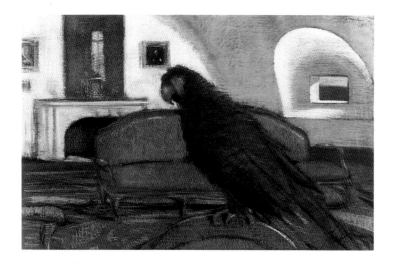

Le Haut rocher, 1984
pastel on paper, 29½ × 43 inches
Private collection

Larraz occasionally presents an ironic view of the passage of time as witnessed by his interior spaces. *State of Alert* of 1984 shows a room in a former fortress. Through the large window an archaic-looking cannon is pointed out to sea. It no longer protects anything but now serves merely as a perch for roosters and hens.

Some of Larraz's most intriguing interiors include animals. In *Intruder* of 1977 and *The Governor's House* of 1981, a monkey is given a central role. In the former picture, the animal plays with several apples atop a table next to a window. At first glance, the scene represented in *The Governor's House* is playful, with its simian creature swinging in an almost empty chamber. Looking closely, however, we observe a revolver on the desk or table at the lower right. No one is in the room to touch the gun, but one cannot help but wonder what role it might play in a more violent scene later on.

Monkeys and apes have played significant parts in iconography throughout the history of art. Since ancient times, monkeys have been employed in various media—painting, sculpture, manuscript illumination—to mock the folly of human beings. The old adage "monkey see, monkey do" has been with us for hundreds of years in various forms of art and illustration. Larraz uses the monkey in a somewhat ambiguous way to

create a compelling atmosphere. Certainly its inherent playfulness is important, but in a scene such as *The Governor's House* in which the animal looks quizzically at a gun, one wonders if the artist is not making a statement regarding the foolish use of weapons by humans.

Larraz has stated that "one of the pictures that has been most influential in my scenes of empty rooms and open windows is Edward Hopper's *Rooms by the Sea* (fig. 9), painted in 1951. I believe it represents the artist's own house in Truro, Massachusetts. Perhaps my painting entitled *Intruder* is the work that most displays my interest in Hopper's image, but there are many more in which it has played a role." Indeed, we see in Hopper's painting a balance between melancholy and optimism similar to that in numerous works by Larraz. As also happens in the art of Larraz, we are taken from the realm of the strictly representational to a slightly more surreal plane, given the abrupt proximity of the water just outside the door of the house in Hopper's *Rooms by the Sea*. In this and many other instances in which Larraz has looked at the art of other painters, he receives visual nourishment in an indirect and highly personal way, transforming an image and imbuing it with his own mark of originality.

Figure 9. Edward Hopper (American, 1882–1967), *Rooms by the Sea*, 1951, oil on canvas. Yale University Art Gallery, New Haven, Bequest of Stephen Carlton Clark, B.A. 1903. (Photo: Joseph Szaszfai)

State of Alert, 1984
oil on canvas, 54 × 81¾ inches
William White, Aspen, Colorado

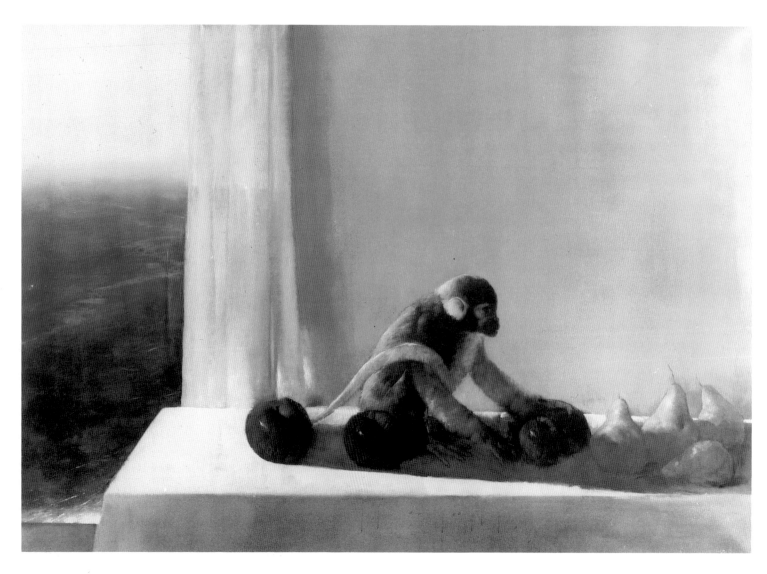

Intruder, 1977
oil on canvas, 44 × 60 inches
Saskia Larraz, Grandview, New York

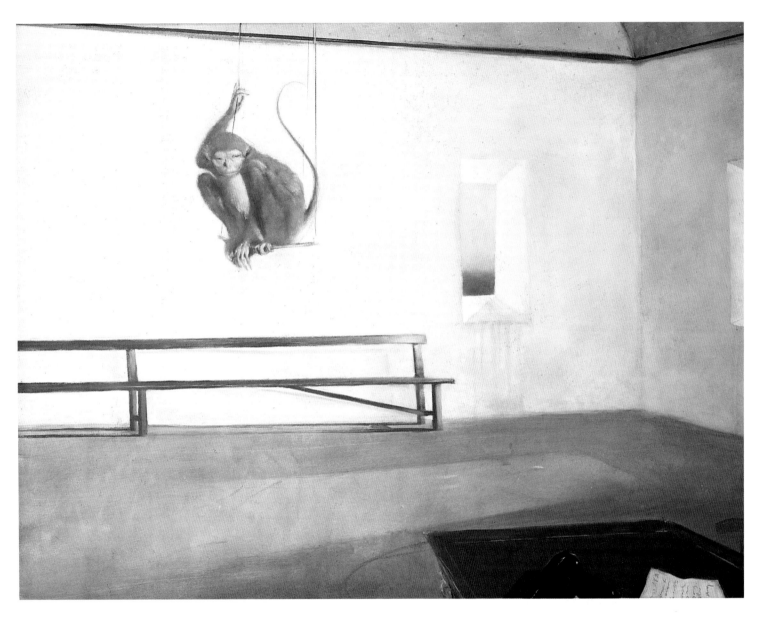

The Governor's House, 1981
oil on canvas, 48 × 60 inches
Ron Hall, Dallas

(Left) *Study for "The Belltower,"* 1982
oil on masonite, 33 × 36 inches
Private collection

Waiting for Henry Morgan, 1984
oil on canvas, 49½ × 47 inches
Private collection

134

Sea, Light, and Sky

Julio Larraz likes to take long walks on the beach at Key Biscayne, near Miami. After the spot where the public beach ends, the shore becomes much more densely foliated, with plants and trees growing up to the edge of the water. Almost no one goes there, and it is the perfect place for the artist to draw and make sketches of the ocean, the clouds, and the plant life. One of the products of his many hours of contemplation and study at this spot is the painting (and several studies) entitled *The Landing* (1986). It depicts a rocky place on the shore with a long line of pine trees in the middle ground. The landscape itself gives the impression of a pristine and undiscovered coast that no humans have polluted with the detritus of civilization so sadly seen on most beaches today. The sense of newness and the illusion of virgin land are contradicted, however, by the presence of a large sail visible above the trees. It appears to belong to an old-fashioned square-rigger, although we see nothing more of it than the large expanse of white canvas. As in the other compositions where human presence is implied, we are made anxious when looking at this picture to know who the sailors of this ship are and what they will do once they land on this beach. Larraz has said that "while standing on a beach such as this and looking out to sea, with no specific references to time and place, you have the feeling of being in any century or in any country. Looking out at the water I often imagine myself to be, for example, in the seventeenth or eighteenth century, with new worlds to discover." This painting is the full embodiment of the artist's expansive imagination.

The Landing, 1986
oil on canvas, 49 × 54 inches
Private collection

In reviewing the large body of Larraz's work, one may have at times the impression that he is almost exclusively a painter of tropical or subtropical climes. The warmth of the southern sunlight seems to be one of his obsessions. The atmosphere he paints appears to be characterized by the crystalline clarity of the air closer to the equator. But certain canvases, painted in many other places, reflect very different climatic circumstances. In *Lights of Tarrytown*, for instance, Larraz suggests a gentle and caressing nighttime ambience. The title of the painting refers to the town on the other side of the Tappan Zee Bridge from the artist's home in Grandview. Houses and lights are only faintly visible in the distance. A colander is spotlighted in the foreground. The colander itself emits light, its holes casting spotted patterns on the ground in an eerie way, almost as if it were some strange spaceship. As René Magritte and some of the other Surrealists did, Larraz conjures up a feeling of ever-so-slight discomfort by using the most mundane objects in unusual ways. Here we are almost obliged to perceive this everyday cooking utensil in a way that we have probably never thought of it before. What may make us nervous, though, is the fact that we are not sure just what it is doing here or where it came from. It may just as easily be an artifact from an alien flying object as a real colander that a child played with in the afternoon and then forgot on the grass as he went home for dinner.

Lights of Tarrytown, 1973
oil on masonite, 47⅞ × 48 inches
Mr. and Mrs. John Duncan, New York

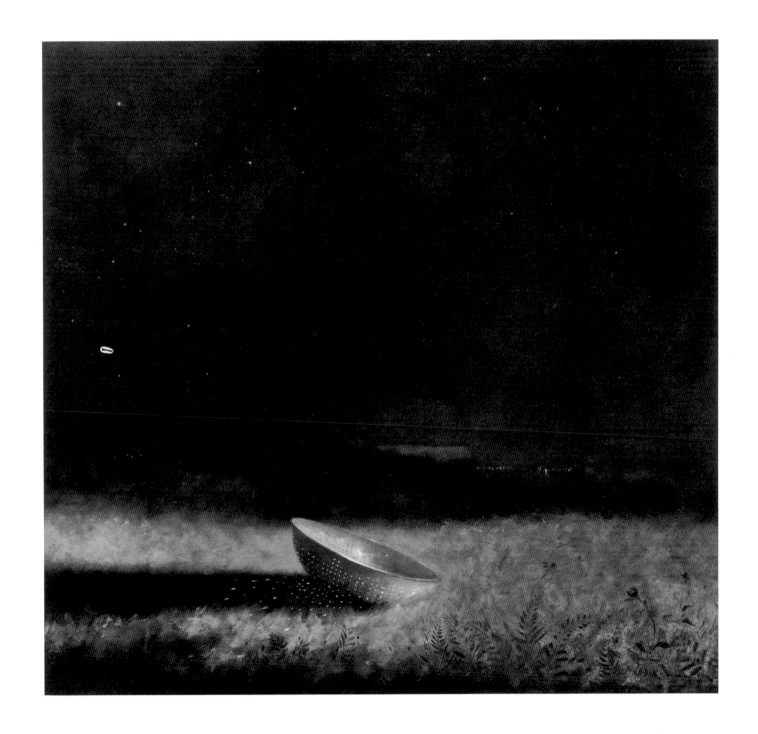

Larraz lived in Paris for a year in 1983–84. During that time he was very productive and created a number of works that also reflect the light and atmosphere of a northerly region. A curious product of his sojourn there is a canvas called *Les Dindons* (The Turkeys). Seen from a low vantage point, ten birds, all white, are posed before us against a starry sky. Their plumage is luxuriant, and the feathery way it is painted complements the treatment of the pine trees in the background. "I painted this picture on a friend's farm in France," Larraz stated. "Not all the turkeys were white, but I wanted to make a harmonic union of all of them."

Another painting concerning birds that Larraz planned but did not execute in France was one depicting pigeons and a dovecote. He made an impressive preliminary painting for the work, however, during 1984. *Study for "Palomar"* shows a small building high atop another structure. It is whitewashed and stands out against the blue sky. Pigeons flutter about its roof, entering and leaving through a narrow window in the center. Although very different in style, this picture is reminiscent of Pablo Picasso's fascination with doves and his own series of paintings of them. In 1957, as he was painting his many variations on Diego Velázquez's *Las Meninas*, he interrupted his work to do a number of poetic studies of pigeons.

Study for "Palomar," 1984
oil on canvas, 23¼ × 24½ inches
Private collection

Les Dindons, 1984
oil on canvas, 37 × 82½ inches
Private collection

Perhaps the most significant idea that germinated in the painter's mind while he was in France was that for his painting *The Escape of General Acapulco*. This is an image of which there are several variations and a number of studies in different media. The picture depicts a large cream-colored house at the right with a red tiled roof. From the upper window hangs a rope apparently fashioned of bed sheets tied together. To the left is a landscape with a view of the sea. In 1984 Larraz did a canvas entitled *Study for "The Escape of General Acapulco"* in France; the following year he executed the definitive version of the picture. It is instructive to note how the work done in Paris places less emphasis on the "tropical" aspects of the scene, which reemerge in the final version. There is, in the earlier canvas, a large cypress tree instead of the palms that replace it later on. The cypress is calm, at rest, but the palm trees in the 1985 picture are tossed about by the wind. In the version done in France, the house resembles a Tuscan villa with a single, classically enframed window. The upper window in the version done in the United States is smaller, and the house is made to appear more tropical or Caribbean by the inclusion of a lower window with shutters and a wrought-iron balcony. The sense of light is also quite different. The illumination of the house in the Paris version is somewhat more filtered, and the surface is defined with a greater mixing of the color tones, whereas in the later version the light is more direct and evenly applied over the entire surface of the picture.

Larraz has said that although the rope does tend to suggest an escape and thus creates of this composition a suspenseful narrative, it is primarily a pictorial device to relieve the plain surface of the house, "to make the viewer interested." Nonetheless, he relates that his original idea for the picture came to him in Paris after he heard an anecdote about a man who had escaped from a hospital where he was confined against his will. The name General Acapulco is also an element of fantasy in this picture, according to Larraz: "I once had a neighbor who was in the military, and a friend of mine would often see him and, for whatever reason, started calling him by that name." The house itself was inspired by the large structure next to his home in Grandview.

The Escape of General Acapulco, 1985
oil on canvas, 72 × 83 inches
Private collection

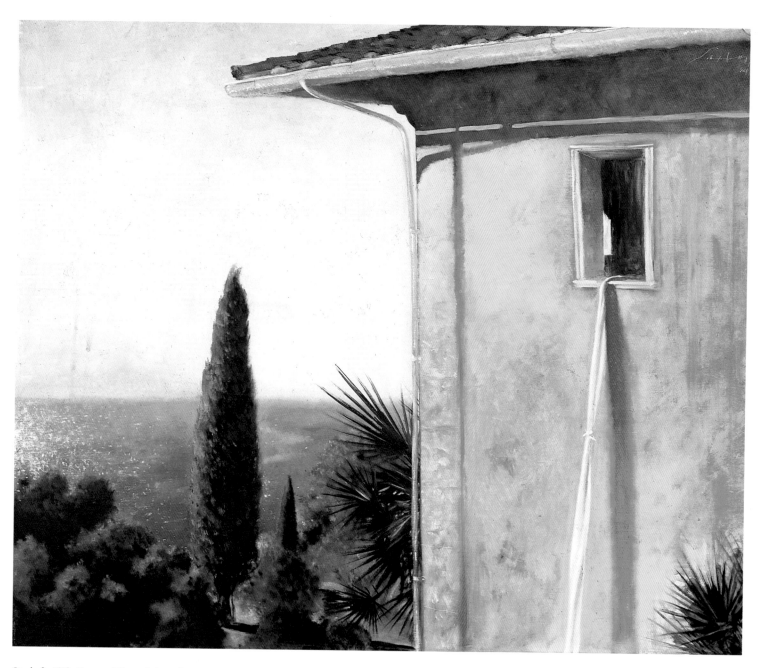

Study for "The Escape of General Acapulco," 1984
oil on canvas, 50½ × 58¾ inches
Burt Bacharach and Carole Bayer Sager, Los Angeles

Study for "The Voice of the Casuarina," 1986
oil on canvas, 18 × 24 inches
Private collection

In 1987 Larraz returned to the theme that was represented in *The Escape of General Acapulco* to do several paintings of the same house seen in a different light and set in a somewhat distinct climate. *The Voice of the Casuarina* and *Study for "The Voice of the Casuarina"* both show a configuration of house and seascape similar to that in the earlier pictures, yet the scene is set amid a starry sky, adding a somber note. This quality is enhanced by the title, which refers to the Casuarina or Australian pine tree, also called a "whispering pine" for the faint sounds made by the wind whistling through its feathery needles.

The house in Grandview also appeared in a 1985 canvas for which he executed a large number of preliminary studies in oil, pastel, and watercolor. *Corridor* depicts the house and a towered structure (a church?) in the upper portion of the canvas. Most of the picture is dominated, however, by a lush green forest landscape of palm trees and other shrubbery through which a steam engine moves as white smoke billows from its stack. The feelings produced by the upper and lower sections of the canvas are somewhat disjunctive. Above we perceive "civilization"—a landscaped area with imposing structures—while below we are shown a glimpse of the virgin

forest only recently cut away to allow the train to pass. The "corridor" of the title refers to the area cleared for the tracks.

Many of the studies for *Corridor* also include familiar elements. The *Study for "Corridor"—Window* presents a view of the train from a vantage point inside a room looking out, while *Study for "Corridor"—Train* gives a close-up view of that element of the final composition seemingly enveloped in the lush greenery.

The theme of the steam engine making its way through a landscape or waiting to begin a journey has a number of links to the art of earlier times. As railway tracks began to crisscross Europe in the 1830s and 1840s, the number of images in both "high" and popular art of trains and train journeys began to multiply. Many of the numerous prints in periodical literature were done to promote locomotive travel or to bolster the public's confidence in this new mode of transportation. In 1844 J. M. W. Turner painted *Rain, Steam, and Speed* (National Gallery, London), which is perhaps the most famous Romantic image of trains. In it, a locomotive emerges from the haze of a London rainstorm as it passes over a railway bridge. Other nineteenth-century representations of train travel include David Cox's *Night Train* of ca. 1857 (City Art Gallery, Birmingham, England), Adolf Menzel's 1847 *Berlin-Potsdam Railroad* (Nationgalerie, Berlin), and Impressionist views of railroad travel such as Camille Pissarro's *Penge Station, Upper Norwood* (1871; Courtauld Institute Galleries, London), Claude Monet's *Railway Bridge at Argenteuil* (1875; Philadelphia Museum of Art, John G. Johnson Collection), and Monet's Gare Saint-Lazare series showing trains in that Parisian station. However, Larraz's picture comes closest in sensibility, subject matter, color, and light not to any European vision of train travel, but to a work by the Mexican plein-air painter José María Velasco, who in 1881 painted *The Metlac Bridge* (private collection, Mexico City), depicting a steaming locomotive traversing a railway bridge cut through dense mountain foliage, including semitropical plants and flowers, in the foreground.

The Voice of the Casuarina, 1985
oil on canvas, 60½ × 60½ inches
Private collection

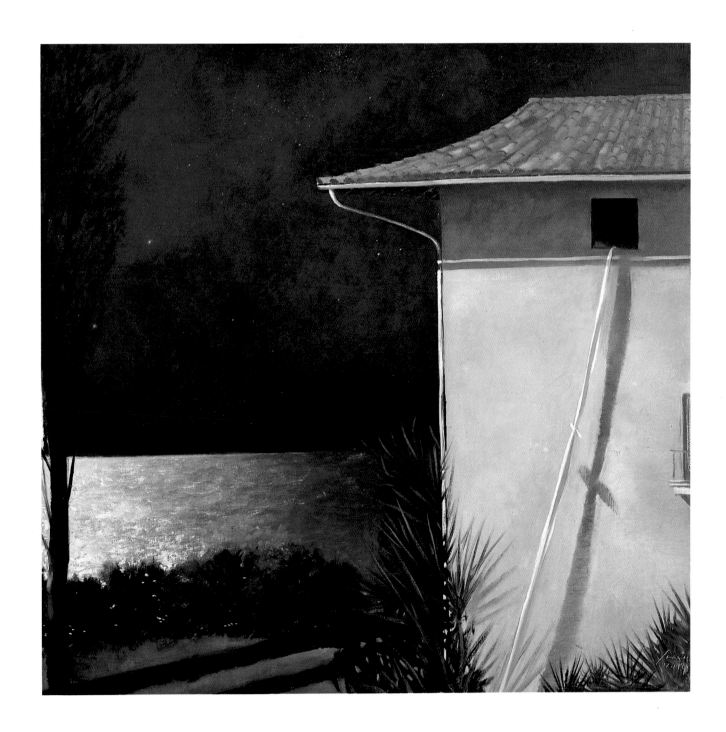

Corridor, 1985
oil on canvas, 54 × 82 inches
Private collection

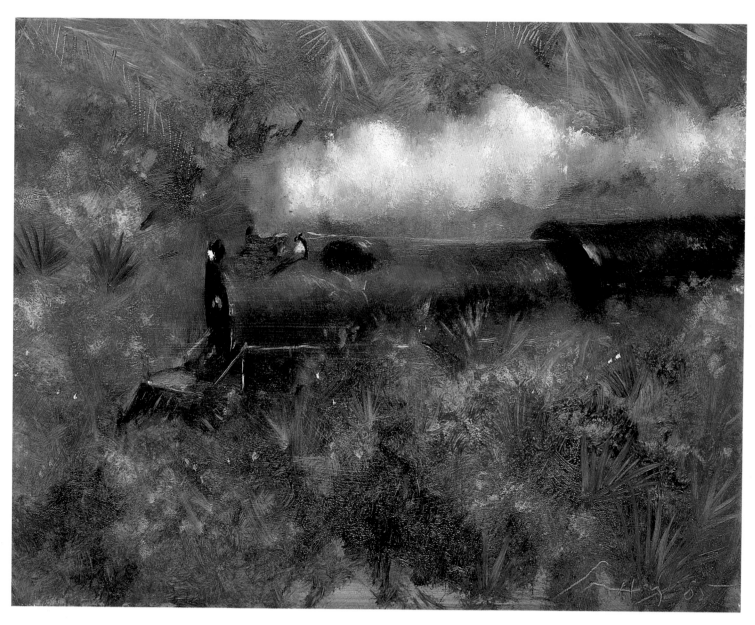

Study for "Corridor"—Train, 1985
oil on masonite, 13 × 16 inches
Private collection

Study for "Corridor"—Window, 1985
oil on canvas, 28 × 28 inches
Private collection

Study for "Corridor," 1985
watercolor, 12³⁄₁₆ × 16¹⁄₁₆ inches
Private collection

Ambush, 1986
watercolor, 51½ × 56¾ inches
Private collection

In many ways the watercolor studies for *Corridor* form a subcategory of work unto themselves. These are extremely impressive pictures concentrating, in a number of cases, on the locomotive. Larraz presents the viewer with an almost scientific description of the powerful engine. All aspects of it—the cowcatcher (the large skirtlike element that is used to clear the track of obstructions), the inside of the engine room, the bells—are studied with equal attention to detail.

Noon Tide of 1985 is one of the numerous pictures related to *Corridor* and is one of the most beautiful of these ancillary studies. The work represents the artist's view into a large body of water reflecting both the swift passage of the train and a cloud formation above it. It has a luminescence and freshness that none of the other works in this series can equal. The concept of looking at recognizable objects upside-down (through their reflections) is curiously parallel to what has been done in the late 1980s by Mark Tansey in at least one of his historical scenes. The use of clouds is more important in this painting than in the others of the group. Clouds have long fascinated Larraz, who has done numerous compositions in which they are the only elements.

"I do cloud studies anywhere I can," Larraz has stated. These have come to form a significant category of his work. They are done in all media and in all sizes and shapes. In fact, some of the most striking of the artist's oil paintings of this subject are executed on round canvases, making the viewer think that he or she is looking through a porthole or the window of an airplane in flight. Larraz's most ambitious cloud composition was done in 1985 as a triptych. *Approach to the Azores* combines an arresting suggestion of flight with the scientifically accurate rendition of masses of clouds. Larraz is fascinated by airplanes and the possibility of being so close to the stratus, cirrus, or cumulus clouds that he paints and draws. There is sometimes an almost baroque element to these cloud paintings. The clouds themselves can be large, puffy, and exuberant, recalling those in the painted ceilings of seventeenth- and eighteenth-century masters who created illusionistic expanses of sky as backdrops for their allegorical or religious figures. Larraz is obviously aware of these affinities, and he has even titled one of his cloud pictures *An Afternoon with Tiepolo.*

The Virgin Flight, 1982
oil on canvas, 60 × 72 inches
Private collection

Noon Tide, 1985
oil on masonite, 48 × 60 inches
Private collection

Approach to the Azores, 1985
oil on canvas (triptych), 80 × 200 inches
Nohra Haime Gallery, New York

Fifteen Knots, 1986
oil on canvas, 61 × 81½ inches
Mitsui and Co. (U.S.A.), Inc.

Larraz has also studied the effects of the sun on different types of clouds. Among his most beautiful works are fairly small-scale pastels on paper that depict the characteristic pinks and yellows of late afternoon or early morning sun on the cloud formations in the Florida Keys. Works like *Marathon*, *No Name Key*, and *Key West* depict the highly distinctive luminescent skies over the many small islands that form this chain.

Although landscape painting developed in the seventeenth and eighteenth centuries, painters rarely, if ever, dignified the simple cloud as a subject for an independent work of art. This did occur in the nineteenth century in the work of numerous masters, most significant among them the Englishman John Constable, who would spend long hours in contemplation of the widest possible variety of clouds to portray in his sketches and paintings. The powerful cloud studies of Pierre Henri de Valenciennes reflect his great respect for these natural phenomena. Cloud paintings by the Norwegian Romantic painter Johan Christian Dahl are actually quite close to those of Larraz with their strong potential for evocation. In the early 1960s Georgia O'Keeffe took up this subject in a series depicting the sky above banks of clouds.

A large number of Larraz's cloud studies have been done in airplanes. "On long flights I become so mesmerized by looking at and drawing the clouds that the time passes without my noticing it." Paintings like the 1986 oils *Waiting* and *Rum & Coke* bear witness to the artist's equal interest with planes themselves. In both of these paintings, small, two- or four-passenger propeller planes are seen. Larraz has demonstrated a fascination with the workings of aircraft, doing drawings and paintings of details such as the wings of jets and propeller planes (for example, the 1983 canvas *Key West Landing*). The planes he paints never have passengers in them. They always appear small enough to land at the smallest of hidden airstrips. Although by no means specific, the messages subtly conveyed to the viewer in pictures like *Waiting* concern elements of mystery and perhaps the imminent arrival on the scene of smugglers of contraband.

Marathon, 1986
pastel on paper, 19¾ × 25⅝ inches
Private collection

No Name Key, 1986
pastel on paper, 19¾ × 25⅝ inches
Private collection

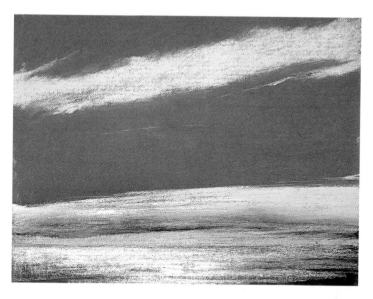

Key West, 1986
pastel on paper, 19¾ × 25⅝ inches
Private collection

The Right Wing, 1983
oil on canvas, 43 × 53½ inches
Private collection

Rum & Coke, 1986
oil on canvas, 44¼ × 83 inches
Private collection

Waiting, 1986
oil on canvas, 50 × 72 inches
Courtesy Nohra Haime Gallery, New York

Key West Landing, 1983
oil on canvas, 35 × 39 inches
Private collection

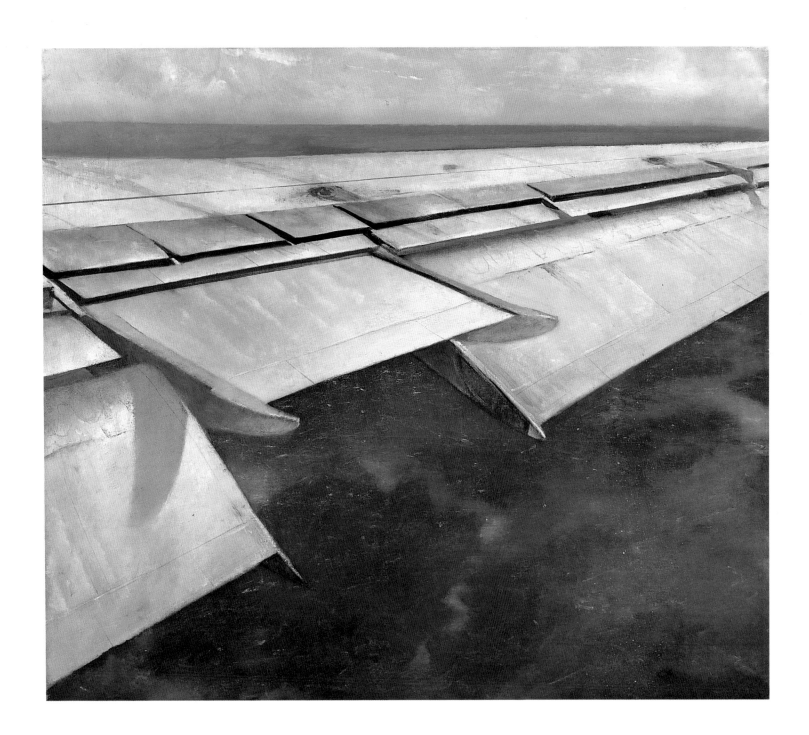

An impression of flight and soaring heights informs the several paintings in the Icarus series and related studies for them. Although the titles are derived from the ancient legend of the boy with wax wings who flew too close to the sun, there is nothing specifically mythological here. The earlier version of *The Fall of Icarus*, dated 1984, is indeed painted from a vertiginous vantage point. From what appears to be hundreds of feet in the air, we look down at the dome of a church by the sea. It is sparkling white with the exception of some brown rust stains that come from the crude wooden cross at the top. To the right of the church is a square with an indistinct equestrian monument in the center, and to the right of that is a cloistered building with a garden in the center. These elements are expanded in the 1986 *Fall*. The artist takes us much higher this time, and we look down upon the same church with the same dome—although it now appears as a tiny dot on the landscape. Boats travel on a canal that runs into the land from the sea. The sky appears clear, except for a tiny dot of light, which may refer obliquely to the legend of the title.

The Fall of Icarus has given rise to several other works that take up motifs present in this painting and expand upon them. One of these is *El Padre de la patria nueva* (Father of the New Country), depicting the square to the right of the church in the first version of the *Fall*. Here we see the equestrian monument much more clearly. It is set on a pedestal and depicts a rearing horse with a rider in military dress wearing a sword, a Latin American military dictator (who also looks a bit like Josef Stalin) in a theatrical pose. The painting expresses an ironic skepticism of this system of ironclad rule. This irony is even more keenly felt in several of the pastel studies where the man's head and torso are shown. In *Study for "El Padre de la patria nueva II"* the stains of time run down the face of the statue. In *The North Wind* two birds sit nonchalantly on the figure of the man—one on his cap and one on his shoulder. There is a feeling expressed here very similar to that in the oil entitled *State of Alert*, where birds perch on an old cannon, unconcerned that it was once a powerful weapon of war.

The Fall of Icarus, 1986
oil on canvas, 85 × 50 inches
Courtesy Nohra Haime Gallery, New York

The Fall of Icarus, 1984
oil on canvas, 56¾ × 81 inches
Courtesy Nohra Haime Gallery, New York

Icarus, 1987
oil on canvas, 65 × 83 inches
Private collection

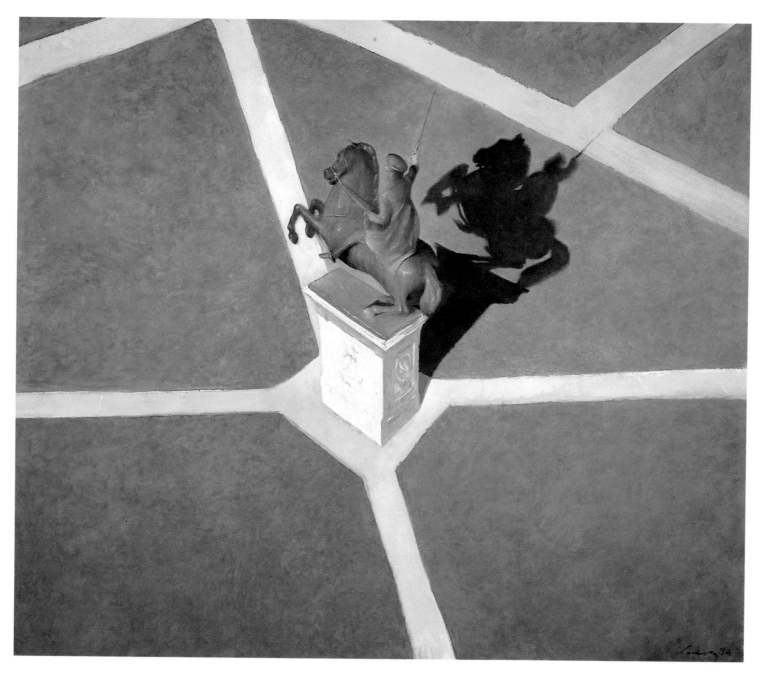

El Padre de la patria nueva, 1984
oil on canvas, 72½ × 82½ inches
Private collection

Study for "El Padre de la patria nueva II," 1984
pastel on paper, 32 × 48 inches
Courtesy Nohra Haime Gallery, New York

The North Wind, 1984
pastel on paper, 29½ × 43 inches
Courtesy Nohra Haime Gallery, New York

Larraz's World

Julio Larraz is in constant contact with the essence of things. When we look at something, animate or inanimate, we generally trust our perceptions to communicate to us exactly what we see. Larraz sees the same things as most of us, but he often stops and contemplates what more they mean to him. He is constantly examining colors and forms, seeing how they connect to the colors and shapes of other related (or totally unrelated) objects. In his homes he lives surrounded by things that he has used or may use in a new painting at any time—maps, multicolored stones, hats of all descriptions—as well as art books that he studies with great relish. Larraz's dialogues with the past are lively and engaging. He understands how artists of other times worked and felt, and he is successful in communicating this understanding to his audience in his inventive transformations of the art of other moments in history.

It is not only the concrete things of the world around us that Larraz innately understands and utilizes, but also those more fugacious states of being and mind. We have seen how there is often an implied human presence in Larraz's paintings. He allows us, in his work, to intuit relationships and emotional interchanges without ever actually showing us clear-cut confrontations between individuals. His powers of suggestion concerning time, place, and humans' involvement with their surroundings or with one another sets the work of Larraz in a class by itself.

Larraz's senses of humor and irony are other important factors in his art. His work is never devoid of emotion, but the emotions are often mixed with multiple layers of meaning so as never to be obvious. Larraz is, for the most part, an artist of subtleties, not of grand statements. Finally, his works are consummately pleasing to the eye. Although his paintings certainly deal with moral and political issues and explore the boundaries of psychological meaning and ramification, they are always constructed in such a way as to amaze us with their originality of composition, their daring use of unexpected juxtapositions of objects, textures, and colors, and their suggestions of poetry and harmonic chords. Larraz is an artist who has sacrificed neither form nor content, and it is this combined clarity of idea and image that will make his art survive and continue to provide visual and emotional stimulation to all who look at it with care.

One Day, 1982
oil on canvas, 60 × 72 inches
Private collection

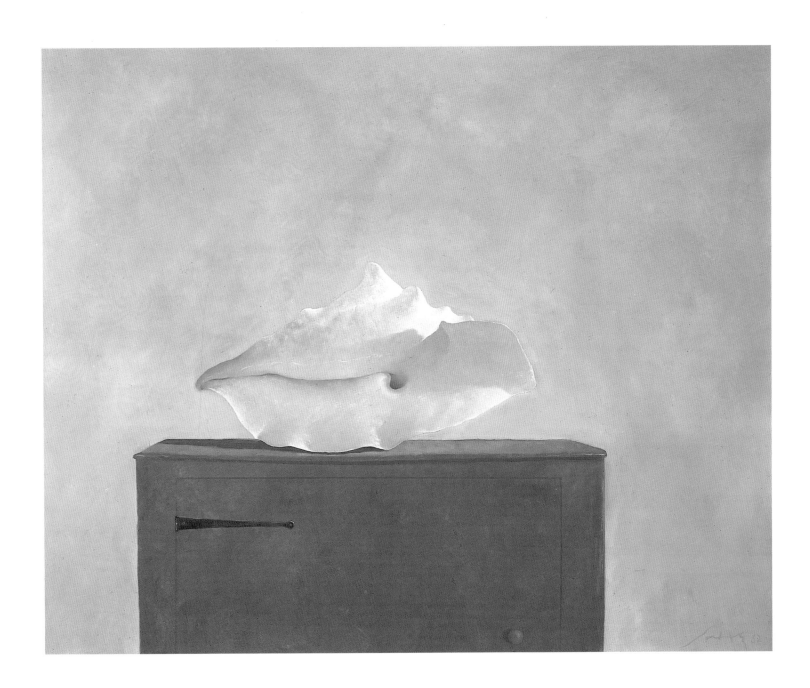

A Conversation with Julio Larraz

Sullivan: In the late 1960s and 1970s you were quite well known for your caricatures. Did this work play a role in the development of your later art?

Larraz: Doing caricatures was something that was important for me. I guess I began to do them while still in school in Havana, and later some of them were published in Cuba. I stopped doing caricatures in the late seventies and don't plan to do any more. Those that I did in the sixties and seventies were very helpful. I had to discipline myself to do things quickly. Precision was important, as I had to capture a concise image of the person I was drawing. Although I no longer do them, their spirit still survives in much of my work. I try to put a certain amount of humor in a lot of my painting, try not to take it too seriously. I admire artists who inject a sense of levity into their work. Claes Oldenburg, for example, does this brilliantly.

Sullivan: Many of your paintings are extremely realistic. Does this reflect a slow or meticulous method of working?

Larraz: I actually tend to work rather fast. I rarely rework paintings. There are times, however, when I really have to fight to get a painting to a state that I'm really happy with. Then I lose all sense of time and begin having my own personal wrestling match with the work. If it's completely impossible I paint over it, but that doesn't happen often. Once in 1979, however, I was desperate to paint and it was Sunday and I couldn't find any canvas, so I took a perfectly good painting, covered it over, and began another. There are, of course, some pictures that I'd like to repaint, but if time passes, it's impossible. I don't glaze my pictures. I don't like a slick look to my paintings, so I do not want them to be varnished.

Sullivan: One of the most oustanding characteristics of your paintings is the textures you portray. How do you evoke the special tactile quality that distinguishes your work?

Larraz: Texture is especially significant for me. When I begin to paint something I feel like I have to know how to create that thing, not just re-create it with paint. I have spent many hours simply observing a variety of wood surfaces in order to portray them in a really honest way. I did the same with cloth weavings to paint their textures. Studying these things has always been an extremely useful tool for me.

Sullivan: Do you do many preparatory drawings for your paintings?

Larraz: I do a great many preparatory studies for my paintings. Many of these are pencil drawings, brief notations of elements which will be a part of the final composition. Sometimes I do drawings of the entire composition to see where the elements fit together. I never consider any of these pencil drawings as finished works in themselves.

The situation is very different with watercolors, though. Now more than ever I'm doing watercolors as preliminary studies for larger paintings; I like the immediacy of the medium. But many of the watercolors are finished products in themselves. However, I almost never do watercolors as studies for still-life paintings. I feel that the only way a still life succeeds is if I paint it directly onto the canvas to give it a sense of freshness and immediacy.

I do many of my watercolors out of doors and also in airplanes for my cloud studies. I carry a small box of colors and my own water and make quick sketches of clouds, which I may later work up on canvas. I also use pastels quite often in preparation for my paintings.

Sullivan: Your landscapes or compositions that take place out of doors rarely have a very specific geographic quality to them.

Larraz: I almost never do paintings that reflect the exact location in which I work, although there is obviously quite often a general suggestion of place. When I spent a year in New Mexico, for example, I didn't do many landscapes of the desert or the countryside around me, yet lots of my pictures of that time have something in them that tends to identify them with my year in San Patricio. I do, however, do watercolors of specific places, like views of the Hudson River near my house in Grandview.

Sullivan: Do you see your work as having gone through specific stages of development or "periods"?

Larraz: Not in a very perceptible way. Since I started painting, my themes and the ways I treat them have been fairly consistent. But a painter is bound to change from year to year—or maybe much more slowly. Someone's career is like the growth of a tree. You can't ever see it growing, but if you've been away from it for ten years and come back, you notice that it's gotten bigger.

Sullivan: The majority of your paintings are in oils. Did you ever use another medium?

Larraz: When acrylics first came out I did some work with them. I painted a couple of portraits, for example, in the early sixties using acrylics. Then I used them for a while as underpainting because they dried quickly. I don't paint with them now precisely because they dry too quickly and one doesn't get the richness that can come from using oils.

Sullivan: Are there any media that you'd like to experiment with in the future?

Larraz: Not any new media, but I'd like to do more with monotypes, of which I have done quite a few, and sculpture, of which I've only done a couple of pieces. I am enthusiastic about these, but one needs access to a press and to a foundry. I think that in the future I'll do more of both of these.

167

Sullivan: At times your works seem to have either a "literary" or a storytelling content, either because of the image itself or because of the title. Do you deliberately try to introduce narrative aspects into your art?

Larraz: I'm certainly aware that this exists, but I don't consciously try to tell any stories in my work. Most often I paint simply what pleases my eyes, but I do admit that I'm sometimes influenced by stories that I hear and then radically change elements of them in my paintings. For example, my series of pictures entitled *The Escape of General Acapulco* is the partial result of a story that someone once told me in Paris. It had to do with a man in the Veterans' Administration Hospital in New York. He'd been placed there against his will and for months hid away bed sheets to use in his escape. When the day came for his escape, he lowered the sheets and found that he'd miscalculated the necessary length by about ten feet. He went down his self-made ladder anyway and fell and broke his leg. He then had to go around to the other side of the hospital to be treated in the emergency room. That story impressed me and made me feel sorry for the man, so I greatly transformed it, added many other elements, and painted those pictures—which essentially have nothing to do with the tale told to me in Paris. As for the titles of my pictures, they are mostly made up so that I can remember what a picture looks like.

Literature itself plays a small role in my work. There have been very few times when I've based a painting on a work of literature. One exception is the *Headless Horseman* that I painted in France, basing my theme, of course, on the tale by Washington Irving, whose home is only a couple of miles from mine in the Hudson River Valley.

Sullivan: Do you consciously borrow any motifs from the history of art?

Larraz: I've never consciously done so, but obviously any artist sees things in other artists' work and they stay in your mind. General themes are, however, suggested to me by others' paintings.

Sullivan: Which artists of the past do you particularly admire?

Larraz: The first that I'd have to mention would be Pieter Bruegel the Elder—both for the brilliance of his technique and for the meanings in his paintings. He was a revolutionary artist in many senses. He lived in an occupied land—Flanders when it was under Spanish rule. His paintings are often indictments of the oppressors of his country. For example, in pictures dealing with the Passion of Christ, his tormentors are usually dressed in the costumes of soldiers of the time.

Insofar as a school of painters is concerned, I'd have to say that the classic Spanish artists are the most interesting to me. I'm fascinated by the dichotomy between artists who seem to paint effortlessly, such as Diego Velázquez, and those for whom painting seems to be a great stuggle, like Francisco de Zurbarán, whose paintings are brilliant, but in them there is something of a woodenness that seems to reflect the difficulty he had in creating them. I guess that of all of them, I admire Francisco Goya the most, especially for his incisive laserlike studies of people and situations of his time. I like his tapestry cartoons the least but am very impressed by his murals for the church of San Antonio de la Florida in Madrid. The portraits are extraordinary, as are his Black Paintings, done at the end of his life. Among that series there's one painting that is, to me, more extraordinary than the others. It's *The Dog*, and in it we see only the head of a dog rising out of the sand. It's like a summation of all the *Pinturas Negras*. The dog seems to me like a privileged spectator of everything that Goya had done. Dogs have a heightened sensibility of the kind that humans don't have. I've always thought that the dog could be a symbol for Goya himself.

Goya's paintings almost seem to have no structure. They appear to be brilliantly structureless, but of course they have a very tight and deliberate structure.

Sullivan: Do you feel that your art can be classified as part of any specific movement in contemporary art?

Larraz: Not really, although it obviously has affinities with the realist movements, and I realize that there are, at times, elements that could be connected to Surrealism in my work too. Among twentieth-century artists, I have a great admiration for Giorgio de Chirico and also for Salvador Dalí—despite his politics. He was a great artist insofar as both technique and imagination are concerned. I am also enormously fond of the paintings of Francis Bacon, and I find an extraordinary power and urgency in his figures. Among American painters, Jasper Johns, Sam Francis, and Richard Diebenkorn are people I look to as enormously significant. In sculpture I am greatly attracted to the work of Giacomo Manzù, to his reliefs in particular. I'd be very interested in doing some experiments with relief sculpture myself, but I'll have to wait until I get further away from Manzù's influence before I attempt it.

Sullivan: You are from Cuba, and your art developed in the United States. Do you feel that American art has had a strong impact on you?

Larraz: Yes, of course. No artist, no matter where that person is from, can help feeling the impact of American art. When I go to museums, it's American art that interests me the most. For my own work I've looked to American artists, especially the masters of watercolor, for inspiration—Winslow Homer, John Singer Sargent, Thomas Eakins. I've learned a great deal from them. They're more important for me than the many English watercolorists, with the exception of J. M. W. Turner, who's a great master.

Sullivan: What, then, are the aspects of your work and artistic personality that can be specifically linked to Latin America? Your work is sold, for example, at specialized auctions of Latin American art, and critics have written about the Latin American characteristics of your work. Do you feel comfortable with this label?

Larraz: Yes, I feel perfectly comfortable being called a Latin American artist. More than anything else, though, I'm a Cuban artist. There are, in my estimation, certain elements that tend to link many Latin American painters together.

Julio Larraz in front of *The Edge of The Storm* and *Ground Control*.

Color is often one, and you can't deny the element of surprise or fantasy in much Latin American art. Gabriel García Márquez said that Europeans or Americans can't really understand the fantasy aspects of Latin America as a whole, and I really agree with this.

Sullivan: Are we correct in reading suggestions of political protest in some of your figure compositions?

Larraz: In a general sense, yes. Latin American political realities do indeed play a role in my work. The theme of the Latin dictator, an endemic illness in our societies, appears a number of times, as in, for example, *President for Life*. In this picture, as in *Mayday*, there is the implication of the possibility of violence and fear. In these works we feel that violence could happen to the persons they depict. On the other hand, though, this and all other paintings are also pretexts for studies of color, texture, and light.

Sullivan: Do you think that works of art can affect political or social situations?

Larraz: In a broad sense I do think so. They certainly will not solve any particular problems in themselves, but they can serve to sensitize people to situations and may stimulate them to begin to do something about a given problem. It's a minor effort that an artist makes, but an important one nonetheless.

Chronology

1944	Born Julio Fernández Larraz on March 12 in Havana, Cuba, to Emma Larraz Sorondo de Fernández and Julio César Fernández. His family owns a major newspaper in Havana, which is run by his parents.
1944–61	Lives with his family in Havana. Attends numerous private (primary and secondary) schools. Begins drawing as a child, although he does not formally study art. Does caricatures, several of which are published in Havana.
1961	Leaves Cuba with his family; goes to Miami, where he remains for one year.
1962	Moves to Washington, D.C.
1963	Moves to Martinsburg, Pennsylvania, where his parents teach Spanish.
1964	Moves to New York City. Works at a wide variety of jobs not related to art. Continues to do caricatures.
1967	Begins to paint seriously. Does not attend art school, but credits David Levine, Aaron Shikler, and Burt Silverman for teaching him techniques of painting.
1969	Marries Scott Mills; moves to Rockleigh, New Jersey. Continues to work with Burt Silverman.
1970	Daughter Saskia born.
1971	Has first exhibition of his work at the Pyramid Galleries Ltd., Washington, D.C.
1972	Son Ariel born. Has exhibition of caricatures at the galleries of the New School for Social Research, New York. Moves to Upper Nyack, New York.
1973	David Levine introduces Larraz to Charles W. Yeiser, director of the FAR Gallery, New York.
1976	With Award in Art from American Academy of Arts and Letters and National Institute of Arts and Letters travels to Europe for the first time; visits France and Italy.
1977	Goes to San Patricio, New Mexico, and remains there working for one year. Meets Ron Hall, his future dealer in Dallas and Fort Worth, Texas.
1978	Moves to Grandview, New York. Divorces Scott Mills.
1979	Meets Nohra Haime, his future dealer in New York.
1983	Becomes an American citizen. Begins a year's stay in Paris (September 1983–November 1984).
1987	Buys house in Miami.
1988	Marries Pilar Botero.

Solo Exhibitions

1971 Pyramid Galleries Ltd., Washington, D.C.

1972 New School for Social Research, New York

1974 FAR Gallery, New York

1976 Westmoreland Museum of Art, Greensburg, Pa.

Edward Hopper Landmark Preservation Foundation, Nyack, N.Y.

1977 FAR Gallery, New York

1979 Hirschl & Adler Galleries, New York

1980 Hirschl & Adler Galleries, New York

1981 Hall Galleries, Fort Worth, Tex.

1982 Works II Gallery, Southampton, N.Y.

Belle Arts Gallery, Nyack, N.Y.

Bacardi Gallery, Miami

Inter-American Art Gallery, New York

1983 Wichita Falls Museum and Art Center, Wichita Falls, Tex.

Nohra Haime Gallery, Foire Internationale d'Art Contemporain, Grand Palais, Paris

Works II Gallery, Southampton, N.Y.

1984 Galería Iriarte, Bogotá

Nohra Haime Gallery, New York

Galería Arteconsult S.A., Panama City

1985 Galleria Il Gabbiano, Rome

Nohra Haime Gallery, New York

1986 Museo de Arte Moderno, Bogotá

Nohra Haime Gallery, New York

1987 Museo de Monterrey, Monterrey, Mexico

Hall Galleries, Dallas

1988 Galerie Ravel, Austin, Tex.

Nohra Haime Gallery, New York

1989 Frances Wolfson Art Gallery, Miami-Dade Community College, Miami

Nohra Haime Gallery, New York

Awards

1975 Cintas Grant, Institute of International Education, New York

1976 American Academy of Arts and Letters and National Institute of Arts and Letters, New York

1977 Purchase Prize, Childe Hassam Fund Purchase Exhibition, American Academy of Arts and Letters and National Institute of Arts and Letters, New York

Group Exhibitions

1974 *American Still Lifes, 1974,* FAR Gallery, New York

Paintings Eligible for the Childe Hassam Fund Purchase, American Academy of Arts and Letters and National Institute of Arts and Letters, New York

The Fine Art of Food, Galleries of the Claremont Colleges, Claremont, Calif.

1975 *Nine Cuban Artists,* Saint Peter's College Art Gallery, Jersey City, N.J.

Art in the Kitchen, Westmoreland Museum of Art, Greensburg, Pa.

Thirty-ninth Annual Midyear Show, Butler Institute of American Art, Youngstown, Ohio

1976 *Candidates for the Art Awards,* American Academy of Arts and Letters and National Institute of Arts and Letters, New York

1977 *A Sampling from the Academy Collection,* American Academy of Arts and Letters and National Institute of Arts and Letters, New York

1977–78 *Recent Latin American Drawings (1969–1976)/Lines of Vision,* organized and circulated by the International Exhibitions Foundation, Washington, D.C.: Center for Inter-American Relations, New York; Florida International University, Miami; Arkansas Arts Center, Little Rock; Archer M. Huntington Art Gallery, University of Texas, Austin; Art Gallery of Hamilton, Hamilton, Canada; Oklahoma Art Center, Oklahoma City

1978 *Image and Illusion,* Squibb Gallery, Princeton, N.J.

Art in Decoration, High Museum of Art, Atlanta

1979　*Modern Latin American Paintings, Drawings, and Sculpture*, Center for Inter-American Relations and Sotheby Parke-Bernet, New York

1980　*Realism and Latin American Painting: The Seventies*, Center for Inter-American Relations, New York, and Museo de Monterrey, Monterrey, Mexico

　　Five Realists, Hirschl & Adler Galleries, New York

1981　*Dibujantes latinoamericanos en Nueva York*, Galería Garces-Velásquez, Bogotá

　　5a bienal del grabado latinoamericano, Instituto de Cultura Puertorriqueña, San Juan, Puerto Rico

1982　*Clouds*, Stuart-Neill Gallery, New York

　　Inaugural Exhibition, Mary-Anne Martin Fine Arts, New York

　　Diciembre en Iriarte, Galería Iriarte, Bogotá, and Bonino Gallery, New York

1983　*Still Life—Thematic Survey*, Zim-Lerner Gallery, New York

　　Maestros latinoamericanos: Obras sobre papel, Galería Arteconsult S.A., Panama City

　　Group Exhibition, Rossi Gallery, Morristown, N.J.

1984　*Artistas latinoamericanos en París*, Galería Arteconsult S.A., Panama City

　　Rotating, Nohra Haime Gallery, New York

　　Summer Group Exhibition, Galleria Il Gabbiano, Rome

1985　*Latin American Artists in New York*, Artconsult International, Boston

　　Pastels, Nohra Haime Gallery, New York

　　Art 12 '85, Basel, Switzerland

　　Gallery Artists—Recent Work, Nohra Haime Gallery, New York

　　The Art of South America, Saint Paul's Companies, Saint Paul

　　Julio Larraz—Hugo Robus, Blue Hill Cultural Center, Pearl River, N.Y.

1985–87　*MIRA*, Museo del Barrio, New York; Hyde Park Art Center, Chicago; Cuban Museum of Art and Culture, Miami; Midtown Art Center, Houston; Arvada Center for Arts and Humanities, Denver

1986　*Landscape, Seascape, Cityscape 1960–1985*, Contemporary Arts Center, New Orleans; New York Academy of Art, New York; City Art Gallery, Raleigh, N.C.

　　V bienal de artes graficas, Museo de Arte Moderno, La Tertulia, Cali, Colombia

　　Maestros en la colección del museo, Museo de Arte Moderno, Bogotá

　　The Mount Aramah Exhibition, Orange County Historical Society, Arden, N.Y.

　　Major Works by Gallery Artists, Nohra Haime Gallery, New York

　　Pastels, Aleman Galleries, Boston

　　International California Art Fair, Nohra Haime Gallery, Los Angeles

1987　*Fifth Anniversary Exhibition*, Nohra Haime Gallery, New York

　　Chicago International Art Exposition, Nohra Haime Gallery, Chicago

　　The Anatomy of Drawing, Hooks/Epstein Gallery, Houston

　　Latin American Artists in New York since 1970, Archer M. Huntington Art Gallery, University of Texas at Austin

　　Watercolors Plus, Nohra Haime Gallery, New York

　　Eccentric Images, RVS Fine Arts, Southampton, N.Y.

　　International California Art Fair, Nohra Haime Gallery, Los Angeles

　　Inaugural Exhibition, Nohra Haime Gallery, New York

1987–88　*Outside Cuba/Fuera de Cuba*, organized and circulated by Zimmerli Art Museum, Rutgers University, New Brunswick, N.J.: Museum of Contemporary Hispanic Arts, New York; Miami University Art Museum, Oxford, Ohio; Museo de Arte de Ponce, Ponce, Puerto Rico; Center for the Fine Arts, Miami; Atlanta College of Art and New Visions Gallery of Contemporary Art, Atlanta

1988　*Nocturne: Portraying the Night*, Kansas City Art Institute, Kansas City, Mo.

　　Blues and Other Summer Delights, Nohra Haime Gallery, New York

　　La naturaleza muerta, Galería Iriarte, Bogotá

1989　*Selections*, Nohra Haime Gallery, New York

　　June Moon—Lunar Reflections, G. W. Einstein Company, New York

Abigail Rose, 1987
oil on canvas, 70½ × 49½ inches
Private collection

Public Collections

Archer M. Huntington Art Gallery, University of Texas, Austin

Cintas Foundation, New York

Miami-Dade Public Library, Miami

Museo de Arte Moderno, Bogotá

Museo de Monterrey, Monterrey, Mexico

University Museum, University of Pennsylvania, Philadelphia

Vassar College Art Gallery, Poughkeepsie, N.Y.

Westmoreland Museum of Art, Greensburg, Pa.

Selected Corporate Collections

American Express Bank, Paris

Armstrong, Teasdale, Schlafly, Davis, & Dicus, Saint Louis

Bacardi Corporation, Miami

Chase Manhattan Bank, New York and Panama City

Dunn & Bradstreet, New York

First Pennsylvania Bank, Philadelphia

Guest Quarters, Florida and Texas

Goodwin, Procter & Hoar, Boston

Haydin Cutler Company, Fort Worth, Tex.

Kaye, Scholer, Fierman, Hays & Handler, New York

Minton Corley, Fort Worth, Tex.

Mitsui & Company (USA) Inc., New York

Preston Carter Real Estate, Dallas

Southeast Banking Corporation, Miami

Tambrands Corporation, Lake Success, N.Y.

W. R. Grace & Company, New York

Westinghouse Electric Corporation, Pittsburgh

World Bank, Washington, D.C.

Wylin Corporation, Texas

Halloween, 1979
oil on masonite, 37¾ × 48 inches
Private collection

Northwest Passage, 1984
oil on canvas, 61½ × 82 inches
Private collection

Bibliography

Alloway, Lawrence. *Realism and Latin American Painting: The Seventies* (exh. cat.). New York: Center for Inter-American Relations, 1980.

Atwood, Judy. "Miami Bacardi Gallery Showing Larraz Works." *Times of the Americas* (Washington, D.C.), 19 January 1983, 8.

Barrera, Yolanda. "Define la obra de Larraz." *El Norte* (Monterrey, Mexico), 29 March 1987.

Bass, Ruth. "Julio Larraz." *Artnews* 87 (October 1988): 178–80.

Betti, Claudia, and Teel Tale. *Drawings: A Contemporary Approach*. New York: Holt, Rinehart and Winston, 1986.

Bourdon, David. " Art: The Canopy Above: Artistic Perceptions of the Skies." *Architectural Digest* 33 (October 1979): 128–33.

————. "New York Reviews: Julio Larraz at Nohra Haime." *Art in America* 75 (March 1987): 142.

Brown, Gordon. "Julio Fernández Larraz." *Arts Magazine* 62 (December 1977): 15.

————. "Art on Paper." *Arts Magazine* 61 (September 1986).

Brubacker, Mary Jean. "Julio Larraz." *Hamptons Newspaper* Southampton, N.Y.), 11 August 1984, 8–9.

Calderón, Camilo. "Julio Larraz." *Al Día* (Bogotá), 19 February 1984, 46–49.

Cassullo, Joanne L. *Julio Larraz* (exh. cat.). Bogotá: Museo de Arte Moderno, 1986.

Chew, Paul A. *Julio Fernández Larraz* (exh. cat.). Greensburg, Pa.: Westmoreland Museum of Art, 1976.

"Continua la exposición de J. Larraz." *El Diario de Monterrey* (Monterrey, Mexico), 3 February 1987.

Correa, Fidelio. "Desde el Museo de Monterrey: Lucia Maya y Julio Larraz." *Aqui Vamos* (supplement to *El Porvenir*, Monterrey, Mexico), 29 March 1987.

Cruz-Taura, Graciella, Ileana Fuentes-Pérez, and Ricardo Pau-Llosa. *Outside Cuba/Fuera de Cuba* (exh. cat.). New Brunswick, N.J.: Zimmerli Art Museum, Rutgers University, and Miami University, 1989.

Dalmas, John. "Julio Larraz." *Sunday Journal News* (Rockland County, N.Y.), 2 November 1975, 1, 3S.

Derbez, Alejandro. "La luz es para el pintor Larraz el recuerdo de su patria." *Tribuna* (Monterrey, Mexico), 29 January 1987.

Derbez García, Edmundo. "Pinta a su Cuba inaccesible." *El Diario de Monterrey* (Monterrey, Mexico), 29 January 1987.

Douslin, P. A. "Julio Larraz." *Art Gallery International* 8 (May–June 1987): 14–18 and cover.

"El nuevo realismo de Larraz." *Vanidades* (Miami) 3 (7 February 1989): 10.

Espinosa, Juan. *Julio Larraz* (exh. cat.). Miami: Bacardi Gallery, 1982.

Finch, Chrisopher. *Julio Larraz: Watercolors and Pastels* (exh. cat.). New York: Nohra Haime Gallery, 1986.

_____. *Twentieth-Century Watercolors.* New York: Abbeville Press, 1988.

Florez, Armando J. "La influencia española de Julio Larraz." *Miami Herald*, 22 December 1980.

García, Fernando. "Julio Larraz pide luz al sol para sus obras." *El Norte* (Monterrey, Mexico), 29 January 1987.

Gil Tovar, Francisco. "Julio Larraz." *El Tiempo* (Bogotá), January 1984.

Haacke, Lorraine. "Handsome Show at Valley House." *Dallas Times Herald*, 5 February 1976, 4E.

Haime, Nohra. *Dibujantes latinoamericanos en Nueva York* (exh. cat.). Bogotá: Galería Garces-Velásquez, 1981.

_____. *Julio Larraz: Recent Work* (exh. cat.). New York: Inter-American Art Gallery, 1982.

Hernández, Raquel. "La pintura es la única forma para crear: Julio Larraz." *ABC* (Monterrey, Mexico), 29 January 1987.

Joubert, Jean. *Julio Larraz* (exh. cat.). Wichita Falls, Tex.: Wichita Falls Museum and Art Center, 1983.

Julio Fernández Larraz: Paintings, Pastels, and Drawings (exh. cat.). New York: FAR Gallery, 1974.

Julio Larraz (exh. cat.). Fort Worth, Tex.: Hall Galleries, 1981.

Julio Larraz (exh. cat.). Monterrey, Mexico: Museo de Monterrey, 1987.

Julio Larraz: New Works (exh. cat.). Dallas: Hall Galleries, 1987.

Julio Larraz: Recent Paintings (exh. cat.). New York: Hirschl & Adler Galleries, 1979.

Julio Larraz: Recent Paintings (exh. cat.). New York: Nohra Haime Gallery, 1984.

Julio Larraz: Recent Paintings (exh. cat.). New York: Nohra Haime Gallery, 1985.

Julio Larraz: Recent Still Lifes (exh. cat.). New York: Hirschl & Adler Galleries, 1980.

McCombie, Mel. "Larraz's Mundane Subjects Radiate Light and Strength." *Austin American-Statesman* (Austin, Tex.), 26 November 1987, F3.

Magnan, Doreen. "Julio Fernández and His Rogues Gallery." *American Artist* 38 (September 1974): 52–57.

Marcos, Regina de. "Pintura: Julio Larraz." *Vanidades* (Miami), 10 December 1984, 12.

Melián, Carmen. "Julio Larraz." *Arte* (Bogotá), December 1988.

Miller, Donald. "Larraz Exhibit Fills Cravings for Realists." *Post Gazette* (Greensburg, Pa.), 18 May 1976, 12.

Monett, Alexandra, and Lowery Sims. *Landscape, Seascape, Cityscape 1960–1985* (exh. cat.). New Orleans: Contemporary Arts Center, 1986.

"New Perspectives, Paintings by Julio Larraz." *Wichita Falls Museum and Art Center Newsletter,* Summer 1983.

Pau-Llosa, Ricardo. "On Latin American Art." *Michigan Quarterly Review* (University of Michigan, Ann Arbor), Spring 1984, 237–42.

"Pintura sin determinante geográfico." *El Porvenir* (Monterrey, Mexico), 29 January 1987.

Quiriarte, Jacinto, Jack Agüeros, and Jim Lichon. *MIRA* (exh. cat.). New York: Hiram Walker and Museo del Barrio, 1985.

Raynor, Vivien. "Art: MIRA at the Museo del Barrio." *New York Times*, 3 January 1986, C20.

_____. "Invitational in Orange County." *New York Times* (Westchester edition), 21 September 1986, 30.

Rodríguez-Dod, Gladys. "Julio Larraz." *Bazaar en Espanol* (Miami), May 1985, 94–97, 105.

_____. "Julio Larraz." *Activa* (Mexico City), 20 November 1986, 15–18 and inside back cover.

Rubiano, Dora. "Realismo mágico en la obra de Julio Larraz." *El Diario-La Prensa* (New York), 19 September 1982, 23.

Sagel, Mariela. "Exposición de Julio Larraz en la Galería Arteconsult." *La Estrella de Panama* (Panama City), 8 November 1984, 14.

Seldis, Henry. "The Fine Art of Food, A Feast for the Eye." *Los Angeles Times*, 24 November 1974, 90.

Siciliano, Enzo. *La luce di Julio Larraz/The Light of Julio Larraz* (exh. cat.). Rome: Galleria Il Gabbiano, 1985.

Silverman, Andrea. "New York Reviews: MIRA." *Artnews* 85 (May 1986): 136–37.

Simon, Sean. "The Inner Island of Julio Larraz." *Artspeak* (New York), 1 May 1988, 6.

Torruella, Susana. "Arte Latino." *Arte en Colombia* (Bogotá) 38 (December 1988), 103–5, 160–61.

Winokur, James L. "Julio Larraz." *Tribune Review* (Greensburg, Pa.), 16 May 1976.

Zelenko, Lori. "Lost Horizons." *Art/World* 11 (December 1986): 4.

_____. "Julio Larraz." *American Artist* 52 (April 1988): 46–51.

Index